MAXFIELD PARRISH

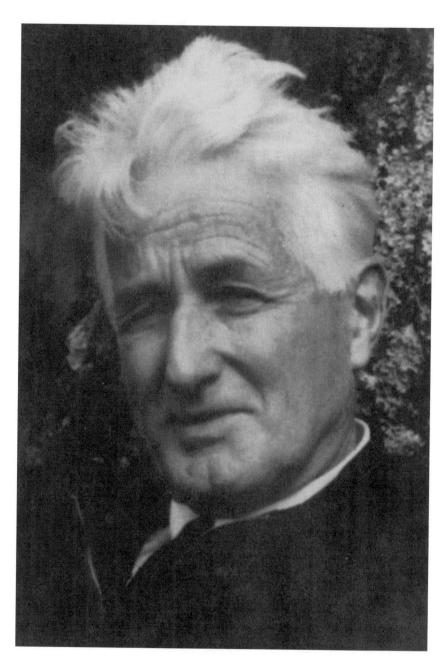

MAXFIELD PARRISH
July 25, 1870 - March 30, 1966

MAXFIELD PARRISH

Identification & Price Guide
3rd Edition

Erwin Flacks

Collectors Press, Inc.
Portland, Oregon

Copyright © 1998 Collectors Press, Inc.

Third Edition, 1998

Printed in the United States of America
5 4 3 2 1

The landscape and winter scenes were
originally published by Brown & Bigelow, Inc.

Library of Congress Cataloging-in-Publication Data

Flacks, Erwin, 1926-
 Maxfield Parrish identification & price guide / by Erwin
Flacks. -- 3rd ed.
 p. cm.
 Includes index.
 ISBN 1-888054-18-2
 1. Parrish, Maxfield, 1870-1966--Collectibles--Catalogs.
I. Parrish, Maxfield, 1870-1966. II. Title.
N6537.P264A4 1998
760' .092--dc21 98-36341
 CIP

For a free catalog write to:

Collectors Press, Inc.
P.O. Box 230986
Portland, OR 97281

Toll-Free 1-800-423-1848

CONTENTS

Dedicated to my wife and best friend, Gail,
who urged me to undertake this book,
assuring me that I could...and to my grandchildren,
Roxanne, Cory, Lindsay, Brian and Casey, who are now
beginning to learn the joy of collecting.

ACKNOWLEDGEMENTS

I would like to thank the following individuals for their contributions over the years: Maxfield Parrish, Jr., Jean Parrish, Coy Ludwig, Harold Knox, Alma Gilbert, Rosalind Wells, Jack Phillips, and Denis C. Jackson, editor of "The Illustrator Collector's News." My wife, Gail, who has an uncanny ability to find delicious Parrish items in remote places, especially when they have escaped my practiced eye. In earlier years, my daughter, Lane, and son, Scott, did the same.

Thanks to Paul Skeeters, author of *Maxfield Parrish, the Early Years*, who spent many happy days photographing my collection for his book. Additionally, I am grateful to the literally thousands of collectors who challenged me to learn more, answer questions, and willingly share their knowledge and experiences. And, of course, a very special thanks to Maxfield Parrish.

"Probably that which has a stronger hold on me than any other quality is color. I feel it is a language but little understood; much less so than what it used to be. To be a great colorist - that is my modest ambition. I hope someday to express the child's attitude towards nature and things; for this is the purest and most unconscious. For after we have 'gone through it all' we seem to come back again some day to our first impressions, with just a bit of worldly experience thrown in to make us conscious how delightful they are."

Maxfield Parrish

INTRODUCTION

In a letter to his son, Dillwyn, on April 10, 1947, Maxfield Parrish from his home in Windsor, Vermont, writes, "It was snowing while writing to you yesterday, but the sun made short work of it, and here dawns a day the weatherman is bragging about. The only snow left now is on the north side of things, and plenty there. It is good once more to hear the robins and bluebirds at sunrise, for all it is below freezing at night: but that is all to the good because it is a good sugar year, something the farmers have not had of late."

This incredible American illustrator "writes" pictures as well as painting them. Had he lived some thirty years more, he would have seen his painting, "Daybreak," hammered down at auction for more than four million dollars. This is the second highest price ever paid for the work of an American illustrator.

Today collectors covet the artworks he created for nearly seventy years. Parrish images appeared in more than one hundred magazines, children's books, art prints, posters, calendars, greeting cards, advertisements, ephemera, and more.

With considerable early support from his father Stephen Parrish, a successful artist in his own right, Maxfield learned to view his surroundings with an analytical eye. His awareness of the environment, whether transferred to canvas, or in letters to family, friends, and businessmen, was gained from his father's teachings. He also learned from his father how to focus attention on details and on natural beauty, shapes, shadows, and light.

His parents took him to Europe when he was in his teens, where he was exposed to and influenced by the grand architecture and elaborate gardens of France, Italy, and England.

Several years of schooling as an architect served him well. At twenty-six, he illustrated *Mother Goose in Prose*, which was first published in 1897. A number of other books followed, including *The Arabian Nights, Dream Days, The Golden Age, The Golden Treasury of Songs and Lyrics, Italian Villas and Their Gardens, Knickerbocker's History of New York, Lure of the Garden, A Wonder Book and Tanglewood Tales*, and *Poems of Childhood*. *The Knave of Hearts*, his last book, was published in 1925.

The Crane Chocolate Company of Cleveland, Ohio, and New York commissioned Parrish to paint images to decorate its candy boxes. The "Rubaiyat,"

"Cleopatra," and "The Garden of Allah" were not only used on the candy boxes but were published as art prints as well. Parrish received about seventy-five thousand dollars in royalties just from the sale of these three prints.

Reinthal and Newman, owners of the House of Art, and Brown & Bigelow, advertising calendar and greeting card publishers in St. Paul, Minnesota, called on Parrish to create paintings for publication as art prints. Parrish painted "Daybreak," "Stars," "Dreaming," and others for Reinthal and Newman's House of Art. "Morning" and "Evening," previously painted and used as *Life* magazine covers, were also published as art prints for the House of Art.

In 1918, General Electric's Edison Mazda lamp division commissioned Parrish to provide paintings for advertising calendars. The first of these images, titled "Dawn," was followed by sixteen annual calendars. These calendars were printed in two sizes. The larger calendar measured 37 inches by 18 inches and was given to the dealer for display purposes. The smaller calendar, 19 inches by 8 ½ inches, was an advertising giveaway. Dealers paid seven dollars per hundred for these calendars, and that included the imprinting of their company name and address. Small celluloid calendars, 3 ½ inches by 2 ½ inches, were placed on the customer counter for pick-up.

Ten of the Edison Mazda images were also used on playing cards. The box cover on these promotional items usually carried the advertising message.

Five calendars, 1920-1924, depicted the history of light. When the final calendar painting, "Moonlight," was returned to Parrish, he painted the figure out. The painting, now without the young maiden, was then published as "Falls by Moonlight." This was not an entirely uncommon practice for Parrish. He painted the figures out of the 1931 Edison Mazda calendar, "Sunrise," and "Atlas Holding Up the Sky" received the same treatment.

The Edison Mazda calendar years, 1918-1934, added still more luster to Parrish's career.

Brown & Bigelow commissioned Parrish to paint the landscapes he was craving to produce, "No more Girls on Rocks!" Beginning in 1936, the B&B era began with "Peaceful Valley" (also titled "Tranquility"), and the artist's title, "Elm, Late Afternoon," and concluded with "Peaceful Country" in 1963. After 1963, Brown & Bigelow reissued previously used landscapes and gave them new titles.

In 1941, Parrish began a series of winter scenes for the greeting cards and calendars that continued until 1962. Unlike the other landscapes, winter

scenes were offered in only one calendar size for each year.

The Brown & Bigelow calendars and prints were published in a number of sizes. The greeting cards were also printed in different formats. Art for some cards was "tipped on," some printed directly on the card, and others bonded to decorated foil card stock.

Parrish's love of the outdoors was illustrated by his longtime residence in Plainfield, New Hampshire. He used the local surroundings in his paintings.

Parrish designed and built his home, "The Oaks." A work of art in itself, the beautiful residence demonstrates his early interest in architecture. The house featured several secret passageways and stairways and was filled with many things Parrish crafted himself. One of the largest spaces was a ballroom with a stage. All the interior woodwork was painted blue, directly reflecting his love for this hue as evidenced in so many of his paintings. This color, often cobalt right out of the tube, came to be known as "Parrish blue."

Rosalind Wells, who purchased The Oaks after the artist's death, found countless articles in secret compartments, cupboards, and hideaways. These items included drawings, paintings and studies, personal letters, cancelled checks, record books, and the like. She contended that Parrish, a typical "New Englander," never threw anything away.

In his studio above the workshop, a one-way mirror allowed him to see individuals entering the workshop. This allowed him to reveal his presence or remain undisturbed.

At one time, a mural he painted was too large to remove from the studio. Parrish cut a long narrow opening in the studio floor so that the mural could be lowered to waiting hands below.

Parrish was fond of his four children, Maxfield, Jr., Stephen, Jean, and Dillwyn. He saw them daily at afternoon tea and became totally engaged with his family while he was with them. His devotion to his family was paralleled by his complete involvement with his painting. No one was allowed to watch him work, and he ate his meals, except for tea, alone.

Parrish was a private person. He disliked reporters. He did not like to be photographed. But, as his stature as an artist continued to grow, he could not entirely avoid the press.

The book, *Maxfield Parrish*, by Coy Ludwig, first published in 1973, still stands as one of the most definitive and comprehensive works about the artist.

Alma Gilbert, an authority and author of many books on Parrish, held

annual exhibitions of his paintings at her prestigious La Galleria, first in San Mateo, California, and then again in Burlingame, California. Gilbert purchased The Oaks, established a museum in the workshop, and opened it to the public.

Maxfield Parrish died at 95 at his home in Plainfield after a long and illustrious career. He was fortunate to see his art grow in popularity, and to realize fame as a great American artist.

His letters to Dillwyn, usually began with "We hied us over to town, and I placed $300.00 (sometimes considerably more), to your account." The letters generally ended, "Here comes the sun through the fog, and a good day is promised, so I'll hie myself to the mailbox. We are promised a new mail carrier. We miss our Mr. Chase no end, who was retired on pension."

We miss our Maxfield Parrish. He has left us a pension, a store of artworks, testimony to his prolific and incredible artistry, to enjoy for generations to come.

Parrish in his early 20s

Parrish at age 50

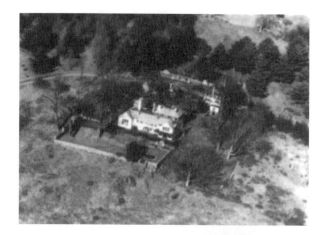

Aerial view of Parrish's
home, "The Oaks,"
late fall 1936

View of the south grounds at
"The Oaks" 1940

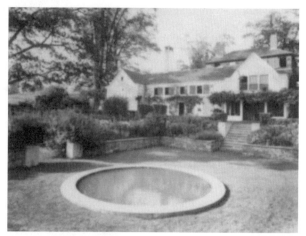

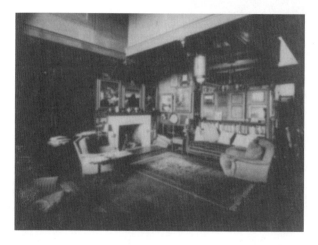

Studio living room at
"The Oaks" 1940

One of the many self-portraits Parrish
took to reveal expressions, shadows
and the natural way clothing drapes
around the human figure.

This self-portrait was used to paint
the Life Magazine cover for
July 20, 1922. Often Parrish would
shoot the photo by tying a string
from his foot to the camera shutter.

Sketch with water colors done by
Parrish at about age twelve.

Parrish often made cut-outs
of figures which he would
use to paint the original.
This one was used for "Stars."

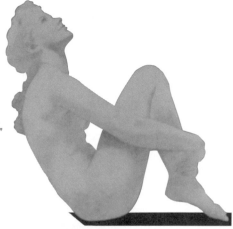

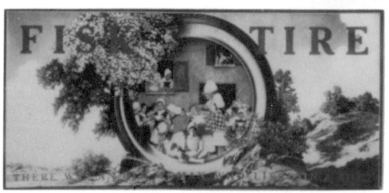

Fisk Tire Ad. "There was an old woman who lived in a shoe." This was a
rare case when the preliminary sketch was approved, but the final oil
painting was not. In a letter from Parrish to Fisk dated 1/27/22 he is
quoted. "The change you request would be folly...to change the
thing...would be more work than to make a new one...it would be cheaper
to pay you back."

Letter from Parrish accepting the challenge of a cover competition for *Ladies' Home Journal*.

Windsor: Vermont.
July 11ᵀᴴ 1903.

My dear Mr. Bok:

I have just returned and found your letter of July 8ᵀᴴ. I should like to have a try at the cover competition, and you may use my name in connection therewith. I have just seen Scribners about the Field pictures and we decided to have them sent here to me if you will be so good, because I want to make a few changes before they publish them, and there is a damaged picture to fix. Is this not?

Sincerely,

Maxfield Parrish.

May 5, 1904.

My dear Parrish:

It gives me great pleasure to tell you that your design, "Castles in the Air," for our Cover Competition has been awarded the first prize, One Thousand Dollars. Check for this amount will go to you in due time. Personally, I am entirely satisfied with this decision, and I am sure you will not quarrel with it. Your beautiful drawing has been admired by every one who has seen it, and we feel that in having the opportunity to publish it, we are subjects for congratulations as well as yourself.

Mr. Bok asked me to extend his cordial good wishes, and suggests that you write about a hundred and fifty words of description, which we will publish in connection with the drawing. The other winners in order of award were, Miss Jessie Willcox Smith, Mrs. Alice Barber Stephens, Mr. Harrison Fisher and Miss Ida Waugh.

Have you made any progress with the Credit?

Kindly let me hear from you, and believe me,

Very sincerely yours,

Art Bureau.

Mr. Maxfield Parrish,
Windsor,
Vermont.

Letter from *Ladies' Home Journal* to Parrish informing him of being awarded first prize for his entry of "Castles in the Air" (Air Castles)

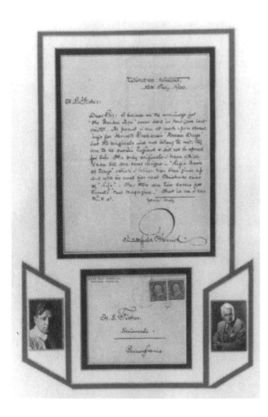
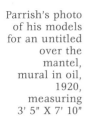

Personal letter from Parrish
to Harrison Fisher informing
him that all the drawings for
Golden Age had been sold.

Parrish's photo
of his models
for an untitled
over the
mantel,
mural in oil,
1920,
measuring
3' 5" X 7' 10"

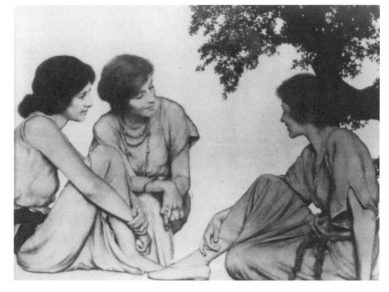

MARKET REVIEW

The sale of the Parrish painting "Daybreak" at auction for more than $4 million and a two part auction of a major collection of calendars, prints, and ephemera at stunning prices, more than justifies the need for a comprehensive *Maxfield Parrish Identification and Price Guide.* This completely updated guide is designed to assist all who have interest in Parrish's highly collectible artwork.

The excitement and energy that are manifest at an auction do not fairly project the prices one might wish to expect to find at antiques shows, shops, or malls. Treasure hunting at flea markets, tag sales, street fairs, and antiques and collectibles "extravangazas" are worthwhile and fun. The values placed on all the items herein are compilations of all the various activities involved in the searching, trading, buying, selling, and discussions with "Parrish People" throughout the country.

It is important to remember that, at best, this is still only a guide. It attempts to reflect current prices with a low and high estimate for each item in its best condition.

Californians and other West Coasters usually have paid higher prices than realized in other parts of the nation. The most desirable situation is to buy in the East and sell in the West.

There are Parrish collectors in all fifty states and around the world. In this guide we have attempted to bridge the gap and provide the reader a range within which one could make a fair determination as to how much to pay or how much to ask when buying or selling Parrish pieces.

Oftentimes, the collector must remember that when selling to a dealer that the dealer has a "profit motive" and will pay less than a serious collector. Obviously, condition, color, rarity, and size are extremely important factors and keep in mind that descriptions of items are subjective. "Good" condition to one may be "fine" or "poor" to another. What is a "slight crease"? Are marginal tears significant? Certainly a complete calendar with a full pad has far more value than one that has been "cropped."

I remember asking a collector friend in Michigan why he paid an extraordinary sum of money for a crease-flawed poster, rare as it was. He responded by asking me if I had ever seen this poster before. When I answered that I had not, he

said, "Neither did I. That's why I bought it!" That made sense to him and, with some consideration, to me.

It may be wise, from time to time, to purchase some rare or unusual item if it is not in the best condition and enjoy it until a better one comes along. With persistence that will happen. I remember searching for a large "Stars" for more than ten years and then finding seven all equally good ones at an antiques show in the same evening. I bought them all.

The same thing occurred a few years later with the book *Mother Goose in Prose*. After searching for this title for more than fifteen years, I found four first editions, all in fine condition, and one autographed by the author at an antiquarian book fair. I could not afford any of them.

Enormous interest in Parrish artwork has spawned countless reproductions. A reproduction may be fine if it serves until you find an original, if that's what you are seeking. Why not enjoy the image while you wait, unless you derive pleasure from being without while you wait.

Dealers have also justified the removal of illustrations from books, matting and framing them to enjoy daily on their walls. Their rationale is that imagery in books lie hidden on bookshelves and are rarely seen for years. Can you argue with that? Some book lovers can and do. Again, this is a subjective matter.

I am often asked how one can tell a reproduction from an original print. "Original" print means it was from the first printing. A practiced eye helps in determining the difference. Follow my advice: buy from collectors or dealers you know. If that is not the case, I suggest you obtain a written receipt. Have the seller indicate in writing that they will refund your money if you learn that what you have purchased is not what was represented. Be sure you receive an address and phone number from the seller. Some collectors or dealers may simply not know whether an item is original.

It is also important to remember that some prices are arbitrary. Many times a dealer will price an item depending upon what it cost him or her.

If you decide to trade or sell some of your items, you can advertise in the newspaper classifieds section or in antique trade papers. You should be cautious about advertising locally because you may place yourself in a vulnerable spot by allowing strangers to enter your home and learn what you have. Exercise good judgment and care.

Increased knowledge will enhance your joy of collecting and provide both esthetic and dollar value for your collection.

THE ENVIRONMENT

The environment into which paper has been placed and the time it has spent there can modify or accelerate the aging process. One or several of the following conditions can bring about the slow, natural deterioration of paper and colors: humidity, temperature, light, and air. Understanding how paper is affected by its environment can help reveal the conditions in which the piece was kept, and what corrective changes, if any, need to be made.

Paper is a hygroscopic substance and, as such, it has a natural tendency to absorb water from the atmosphere. This quality enables it to be flexible and supple. This is why museums of fine art are humidity-controlled. Ideal humidity is between 45 to 55 percent at a temperature of 68 degrees Fahrenheit with a tolerable variance of 5 to 10 degrees. Air conditioners, humidifiers or dehumidifiers can effectively establish a suitable atmospheric condition for art printed on paper.

When there is insufficient humidity, paper will become stiff and brittle. Prolonged exposure to this condition can destroy the paper. If this condition is not too advanced, the paper can regain its suppleness when it is moved into the correct atmosphere. If damage is serious or permanent, it will be necessary to reinforce the piece with patches or a lining of paper.

Excessive humidity can soften paper, causing it to expand and change shape. Crinkles, warping, bulges and waves become excessively pronounced if the dampness is unevenly spread. Placing the paper in the correct environment can help to restore it, but if the paper is excessively distorted, pressing it out may improve its appearance. There are many methods of doing this, none of which is sure to give you perfect results. Because there are so many opinions on this subject and so many different kinds of paper, we recommend that you contact a professional conservator for advice.

During the original framing process and other periods when the paper itself was handled, oils and grease from hands and from the air may have settled on the paper. Years may pass before the paper is placed in an unfavorable environment. Humidity and temperature can cause these micro-organisms to become active and spread, revealing themselves to the naked eye. Their appearance is of small brownish-grey to black spots dispersed unevenly throughout the paper. In more extreme situations, these dots will tend to group together and

permanently damage the paper.

Air acts as a vehicle for dust, spores, and bacteria. It also activates the chemical components in paper. These pollutants can catalyze the impurities in paper and transform them into acids that can destroy the cellulose fibers in the paper.

Air also carries greasy dust, ash, and other particles which lodge in the pores of paper and then darken its surface, often forming stains that are not removable. Soaking the paper in a water bath with a trace of mild soap, such as Ivory, can often remove this type of stain, but it softens the paper, making it susceptible to tearing. There are mixed opinions as to what chemicals to use or not use when soaking, the amount of time to soak the paper, and techniques for drying. It is always best to consult a professional conservator rather than experiment on your own. You could easily end up making the situation worse, or even destroying your work of art.

Obviously, light is necessary for the enjoyment of your piece; it is, nonetheless, a notorious enemy of paper. Both natural and artificial light emit radiation that is damaging to paper. It is the photochemical reaction of these rays with the impurities in paper that causes a breakdown of the cellulose fibers; causing colors to become bleached or yellowed. Many colors fade when exposed to light, causing irreparable damage. For this reason, it is important to limit the amount and duration of light used for display and examination.

Underexposure to light, in combination with humidity and inadequate ventilation, on the other hand, can create conditions in which micro-organisms and small insects can thrive. As you can see, the environment plays a large role in the condition of paper and can directly affect its longevity and value.

REPRODUCTIONS

The word "reproduction" in Parrish collecting frequently means new or fake or just not of the period from which the original was painted. Since original oils are not bought and sold in nearly the numbers that prints and other items are, the word "original" gets altered into meaning a "period piece" or printed during the period from which the original was painted. We will refer to a reproduction as either a "new reproduction" or an "original reproduction" (from the period in which the oil was painted). It seems that as we see more and more new reproductions on the market, those two words "reproduction" and "original" become increasingly distanced from their true meanings.

The existence of these later reproductions can cause problems for the unsuspecting or uninformed buyer. For those who do not have a preference between the two, a much less expensive new reproduction may be suitable and certainly more affordable. The following section is based upon the experiences of collectors and dealers who have learned, sometimes the expensive way, how to distinguish a new reproduction from an old one. The following will not make you an expert, but it will give you a better understanding of the fraudulent activities that exist and possibly help prevent a costly mistake.

Since the 1960s there has been a steady renewal of interest in the work of Maxfield Parrish. New reproductions are appearing more frequently, and the old ones are becoming more sought after. Thirty years later, reproductions of his work are still being made, and with the increasing value of his original prints, the market for the less expensive, new reproductions is larger than ever.

The evolution of the printing process has made it more difficult to distinguish a new reproduction from an old one. As a result, parties may sell new reproductions as old ones without even knowing the difference themselves. In other cases, the seller may have purchased the new reproduction by mistake and now wants to recover the loss. Still another circumstance is when a crafty individual who purchases a new reproduction, dips it in diluted coffee or tea, dries it in the sun for a few hours, then frames it in a period frame and tries, usually with good success, to sell it as an original. To complicate matters more, some will carefully peel back the old paper

backing just enough to allow the removal of some of the nails and then lift the mat up, take the old print out and replace it with a new reproduction. The mat and nails are then put back and the old paper back reglued to the frame. Some even take the old paper backing from a larger frame, glue it to the back of the smaller reproduction's frame and then trim the edges to give it the appearance of an original. This is a very good reason never to assume that just because the paper backing is intact you have an original reproduction.

This situation is rarely found in a reputable shop but is more likely to occur in smaller auction houses where the description of the item is vague and the terms "bought as is, where is," and "you be the judge" apply. Careful examination during preview is essential. It is the surest way of avoiding buyer's remorse and unnecessary disputes after the auction is ended.

The term "original backing" and its effect on value and originality are often contradicting. Many Parrish collectors and dealers prefer to remove the old paper backing and cardboard matting and replace it with a fresh, clean rag board (acid-free matting) and new paper. A surprising number of them call the sole use of this rag board "museum framing" and use this term as an added tool for selling the art. Museum or conservation framing does involve the use of rag board, but it also incorporates linen or rice paper hinging, as well as matting. When matting is not desired, acid-free spacers are used to achieve the same purpose which is to keep the piece away from the glass so that condensation does not form.

There are times when a piece should be reframed. The acids in the old wood pulp mat boards may be causing damage to the piece that is visible to the eye. It could also be necessary because moisture may have gotten inside at some point causing the mat to rot; then it may be just a matter of time before the piece gets damaged if it is not already.

There are claims that removing the original backing lowers the value of the piece and makes it somewhat more difficult to sell. Several reputable auction houses in the United States agree that even when they guarantee that the piece is original, it still does not bring bidding characteristic of that for original-backed prints. In fact, some of these auction houses will not even take on consignment reframed Parrish. If you are considering purchasing a reframed Parrish, you may want to ask why it was reframed and have the seller explain the method used.

Measuring a Parrish is one of the most important means of determining

originality. The term "cropping" is used to describe a piece that has been cut down in size usually because damage existed around the edges. It also may have been cropped to fit a frame. Many times during the period in which the original reproductions were made, the purchaser might have a special frame to be used and would cut an art piece down to fit it. This is unfortunate but true and, in either case, cropping can greatly lower the value of a piece. If, when you measure a piece, it is smaller than what it should be, but the entire picture is there, you may have a reproduction. If the piece is larger than what it should be, you may likewise have a reproduction. There are occasions when the art may have been subject to moisture and temperature variations, in which case the piece may have contracted or expanded. For this substantially to affect the measurement, you will most likely see visible damage of the type described in this guide in the section on damage. In some cases, new prints are being made that will measure exactly the same as old ones. For this reason, you should never rely on just one or two criteria in making your decision as to authenticity.

New reproductions look new. Most of them are shiny with a surface appearance that looks similar to vinyl. Their colors are usually much more brilliant than those of the original reproduction. Details, as in the new poster books, look fuzzy in shaded areas and lack the same detail of the originals. Their color also has a kind of brassy look that is quite easy to identify once you have seen it. Purchasing a poster book and a couple of new print or calendar reproductions is an excellent way to familiarize yourself with identifying new reproductions. Most of the antiques shows and some of the publications will offer these for sale at substantially lower prices than those of the originals.

Another way of spotting a reproduction is by using a jeweler's loupe or a magnifying glass to see the dot pattern of the paper. This techique requires hands-on experience that can be gained by repetitious examination of the old in comparison with the new.

If you encounter a Parrish that is not in a frame, determining if it is an original is fairly easy. Old paper looks and feels old. The paper is generally heavier than what has been used over the past thirty years, and the back side is usually anywhere from a very light brown to dark brown. This is patina, a film that gradually appears on the surface from age. It will also occur on the front side, but on the back it is much easier to observe because it was usually white during the original printing. Cigarette smoke, wood burning stoves, fireplaces, and residual smoke and grease from cooking will also add to this discolorization.

Generally, all prints fade to some degree. Looking at the piece printed side up, you will commonly see a border where the original or near-original color still exists. The severity of fading, however, may not be directly related to age. Much will depend upon the amount of light and length of time the print spent exposed to it.

Attending antiques and collectibles shows is an excellent place to see a variety of Parrish, and a great place to compare the new with the old. Take the opportunity to ask a lot of questions from the dealers who are selling his work. The honest Parrish dealers will be happy to engage in conversation with you as they, too, have a passion for the artist's work and want to help educate their market. After a while, identifying new reproductions will be easier, but just when you think you have it down, something new will come out of the woodwork; maybe a new printing method, or an aging technique not already known. Just remember to never assume. Always keep in mind the basics, carry this book with you, and don't be reluctant to ask as many questions as you like.

NEWER REPRODUCTIONS

With the continual advancement in printing technology, reproductions will look more and more authentic and will be made in sizes to match the old.

The following is a list of known titles of Parrish reproductions printed for mass marketing from the mid-1960s to the present.

Air Castles
Aladdin and the Wonderful Lamp
An Ancient Tree
Apple Man
April Showers
Aquaboard
Aquamarine
Arizona
Atlas
The Boar's Head
The Botanist
Buds Below the Roses
Canyon
Cadmus Sowing the Dragon's Teeth
Century Poster
The Chaperone
Christmas Toast
Church at Norwich, Vermont
Cleopatra
Collier's Funnygraph
Columbia Bicycle Posters
Come and Do Your Bite
Comic Scottish Soldier
Contentment
Crane Chocolate ad
A Dark Futurist
Daybreak
Deep Woods, Moonlight
A Departure
Dies Irae

The Dinkey-Bird
Djer-Kiss ad – Girl on Swing
Dreaming
Dreamlight
Dusk
Ecstasy
Egypt
Egypt, The Three Caskets
Enchanted Prince
Enchantment
The End
Eve Eating the Apple
Evening
Evening Shadows
Falls By Moonlight
The Fisherman and the Genie
Florentine Fete
Fly-Away Horse
Formal Growth in the Desert
Frog Prince
Garden of Allah
The Glen
Golden Hours
Graduation Party
Griselda (Enchantment)
Harvest
Hilltop
The History of Codadad and His Brothers
Humpty Dumpty
The Idiot

Indian Drinking Rum
Interlude
Its Walls Were as of Jasper
Jack and the Giant
Jason and His Teacher
Jello ad – King and Queen
Jello ad – Polly
John Wanamaker Painter's Palette
Just a Moment Please
King of the Black Isles
The Knave and Lady Violetta
Knave Watches Lady Violetta Depart
Lady Violetta
Lady Ursula Kneeling Before
 Pompdebile
Lampseller of Bagdad
Land of Make- Believe
Lantern Bearers
Lute Players
Masquerade
Millpond
Misty Morn
Moonlight
Morning
Morning Light
Mutabile Semper, Chocolate
New Hampshire: The Winter Paradise
New Moon
Old Glen Mill
Ottaqueeche River
The Palace Garden
Panel for the Florentine Fete
Parading Soldiers
Peaceful Valley
A Perfect Day
Pied Piper
Poster Show
Presentation Design
Primitive Man
The Prince

Prometheus
The Prospector
Puss-N-Boots
Queen Gulnare
Quiet Solitude
Reluctant Dragon
The Reservoir, Villa Falconieri
Reveries
The River at Mt. Ascutney
Riverbank, Autumn
Romance
Rubaiyat
Saga of the Sea
Scribner's August
Sheltering Oaks
Shuffle Shoon and Amber Locks
Sleeping Beauty
Sinbad Plots Against the Giant
Snowdrop
Solitude
Spirit of the Night
Spring
Stars
Sugar-Plum Tree
Sunlit Valley
Sunrise
The Tempest
Tranquility
Twilight
Under Summer Skies
Venice – Twilight
Venetian Lamplighter
Venetian Night's Entertainment
Villa Scassi
Waterfall
White Birch
Wild Geese
With Trumpet and Drum
Young Maiden by Tree

Early 1970s poster of reproductions. The poster
itself is valued at $100-$125

Early 1970s poster of reproductions. The poster
itself is valued at $100-$150

Contemporary page from a catalog offering Parrish reproductions.

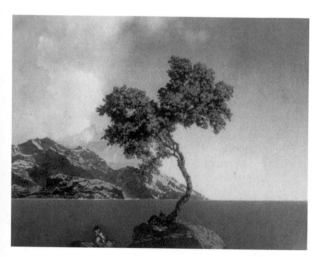

New reproduction (1993)
Limited edtion print
"Aquamarine"
12 1/2" X 16"
$125

THE PRINTS

"There is a constant demand for pictures to be used as prints as it saves re-papering the wall's (sic) of young ladies' seminaries."

Maxfield Parrish
February 1, 1922

AIR CASTLES
1904

12" X 16" / $275-$350
Ladies' Home Journal

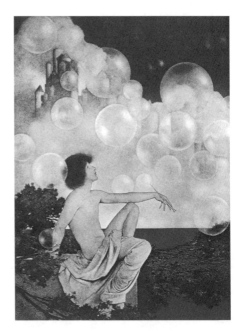

ALADDIN AND THE
WONDERFUL LAMP
1907

From *The Arabian Nights*
9" X 11" / $140-$160
P.F. Collier & Son

ATLAS
1908

From *A Wonder Book
and Tanglewood Tales*
9 1/2" X 11 1/2" / $175-$200
P.F. Collier & Son

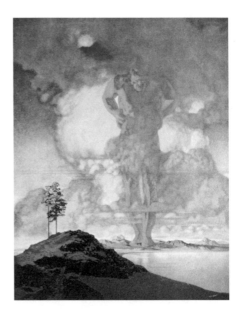

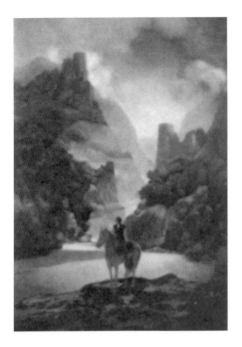

AUCASSIN SEEKS FOR NICOLETTE
1903

11 1/2" X 17" / $475-$510
Charles Scribner's Sons

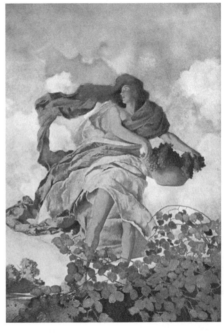

AUTUMN
1905

From *The Golden Treasury
of Songs and Lyrics*
10" X 12" / $185-$235
P.F. Collier & Son

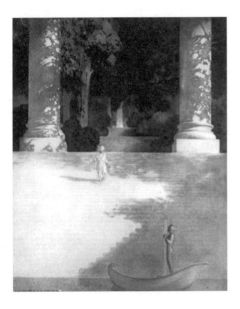

**THE LANDING OF THE
BRAZEN BOATMAN**
1907

From *The Arabian Nights*
9" X 11" / $150-$175
P.F. Collier & Son

THE BROADMOOR
1921

6 3/4" X 8 1/2" / $150-$175
17 1/4" X 22" / $500-$550

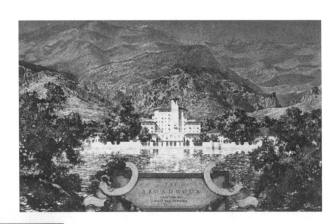

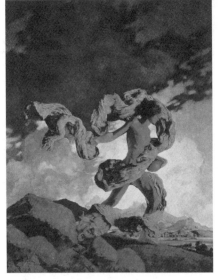

CADMUS SOWING THE DRAGON'S TEETH
1909

From *A Wonder Book and Tanglewood Tales*
9 1/4" X 11 1/2" / $145-$165
P.F. Collier & Son

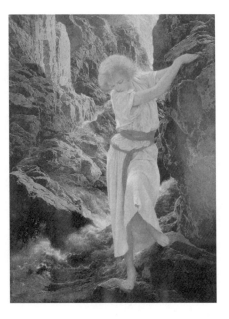

THE CANYON
1924

6" X 10" / $135-$150
12" X 15" / $275-$325
House of Art

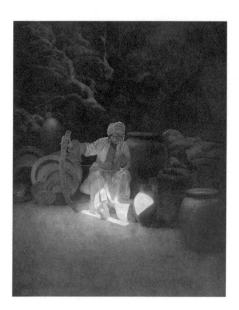

CASSIM
1906

From *The Arabian Nights*
9" X 11" / $165-$185
P.F. Collier & Son

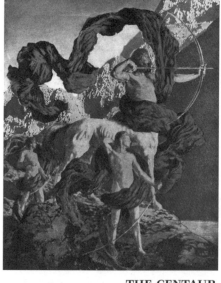

**THE CENTAUR
(JASON AND HIS TEACHER)**
1910

From *A Wonder Book
and Tanglewood Tales*
9 1/4" X 11 1/2" / $150-$175
P.F. Collier & Son

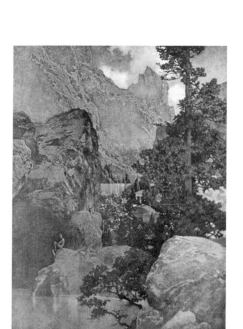

**THE CHIMERA
(BELLEROPHON)**
1909

From *A Wonder Book
and Tanglewood Tales*
9 1/4" X 11 1/2" / $190-$225
P.F. Collier & Son

CIRCE'S PALACE
1908

From *A Wonder Book
and Tanglewood Tales*
9 1/4" X 11 1/2" / $185-$225

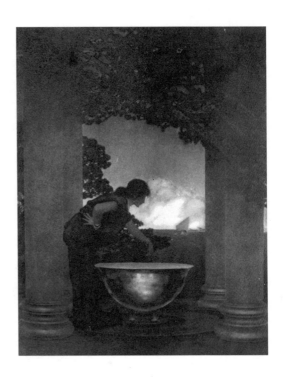

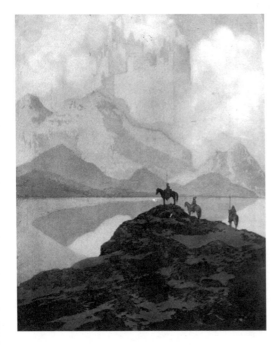

CITY OF BRASS
1905

From *The Arabian Nights*
9" X 11" / $140-$160
P.F. Collier & Son

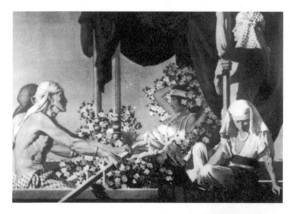

CLEOPATRA
1917

6 1/4" X 7" / $250-$300
13 1/2" X 15 1/2" / $600-$750
24 1/4" X 28" / $1800-$2300
House of Art

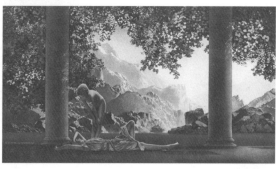

DAYBREAK
1923

6" X 10" / $100-$165
10" X 18" / $250-$325
18" X 30" / $400-$550
House of Art

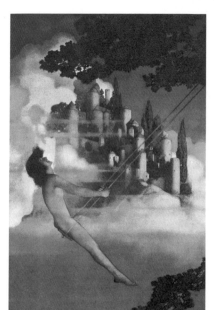

THE DINKEY-BIRD
1905

From *Poems of Childhood*
11" X 16" / $275-$350
Charles Scribner's Sons

DREAM GARDEN
1915
14" X 24 1/2" / $550-$675
Curtis Publishing Company

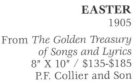

DREAMING
1928

6" X 10" / $200-$250
10" X 18" / $550-$700
18" X 30" / $1400-$1700
House of Art

EASTER
1905

From *The Golden Treasury
of Songs and Lyrics*
8" X 10" / $135-$185
P.F. Collier and Son

ERRANT PAN
1910

9" X 11" / $195-$245
Charles Scribner's Sons

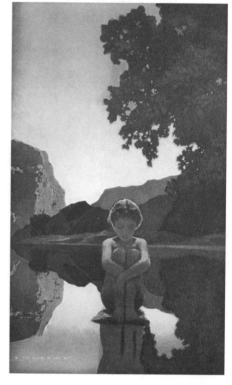

EVENING
1922

6" X 10" / $150-$185
12" X 15" / $300-$400
House of Art

THE FOUNTAIN OF PIRENE
1907

From *A Wonder Book
and Tanglewood Tales*
9 1/4" X 11 1/2" / $170-$200
Charles Scribner's Sons

GARDEN OF ALLAH
1918

4 1/2" X 8" / $100-$145
9" X 18" / $250-$350
15" X 30" / $450-$550
House of Art

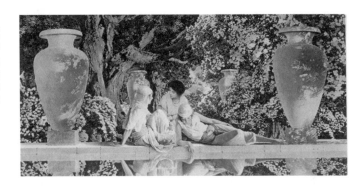

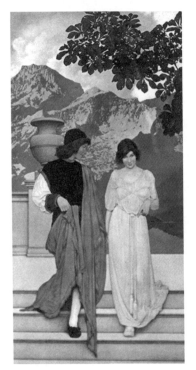

GARDEN OF OPPORTUNITY
1915

10 3/4" X 20 1/2" / $525-$600
Curtis Publishing Company

THE GARDENER
1907

13" X 19" / $250-$300
P.F. Collier & Son

HARVEST
1905

From *The Golden Treasury
of Songs and Lyrics*
8" X 10" / $235-$275
Dodge Publishing Company

HILLTOP
1927

6 1/4" X 10" / $150-$175
12" X 20" / $400-$550
18" X 30" / $850-$1000
House of Art

**HISTORY OF THE FISHERMAN
AND THE GENIE**
1906

From *The Arabian Nights*
9" X 11" / $130-$150
P.F. Collier & Son

THE IDIOT or BOOKLOVER
1910
8" X 11" / $235-$275
P.F. Collier & Son

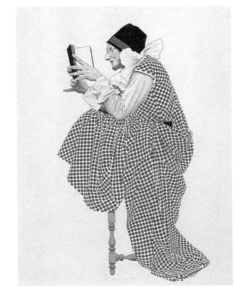

INTERLUDE
1924

(See "The Lute Players")
12" X 15" / $300-$350
House of Art

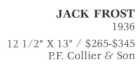

JACK FROST
1936
12 1/2" X 13" / $265-$345
P.F. Collier & Son

JASON AND THE TALKING OAK
1908

From *A Wonder Book
and Tanglewood Tales*
9 1/4" X 11 1/2" / $140-$165
P.F. Collier & Son

KING OF THE BLACK ISLES
1907

From *The Arabian Nights*
9" X 11" / $150-$185
P.F. Collier & Son

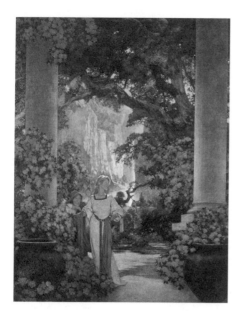

LAND OF MAKE-BELIEVE
1912

9" X 11" / $250-$275
Charles Scribner's Sons

THE LANTERN BEARERS
1910

From *The Golden Treasury
of Songs and Lyrics*
9 1/2" X 11 1/2" / $275-$350
P.F. Collier & Son

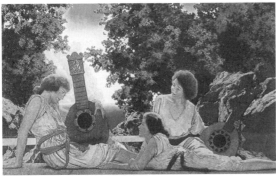

THE LUTE PLAYERS
1924

(See "Interlude")
6" X 10" / $150-$175
10" X 18" / $325-$375
18" X 30" / $700-$850
House of Art

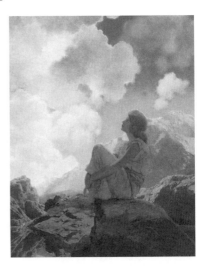

MORNING
1922

6" X 10" / $125-$150
12" X 15" / $275-$350
House of Art

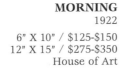

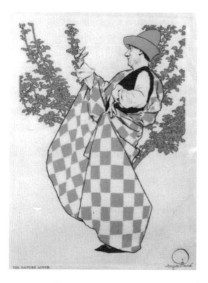

THE NATURE LOVER
1911

10" X 13" / $225-$275
P.F. Collier & Son

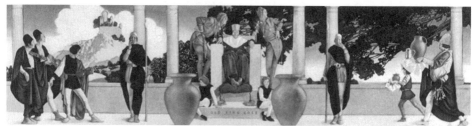

OLD KING COLE
(ST. REGIS)
1906

3" X 11 1/2" / $350-$475
6 1/4" X 23" / $1300-$1500
Dodge Publishing Company

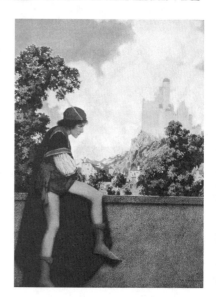

THE PAGE
1925

From *The Knave of Hearts*
9 3/4" X 12" / $200-$250
House of Art

PANDORA
1909

From *A Wonder Book and Tanglewood Tales*
9" X 11" / $150-$225
P.F. Collier & Son

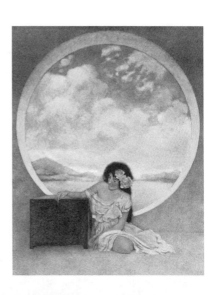

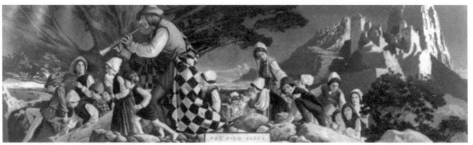

PIED PIPER
1909

6 3/4" X 21" / $1000-$1250
P.F. Collier & Son

PIERROT'S SERENADE
1908

From *The Golden Treasury of Songs and Lyrics*
9 1/2" X 11 1/4" / $145-$200
P.F. Collier & Son

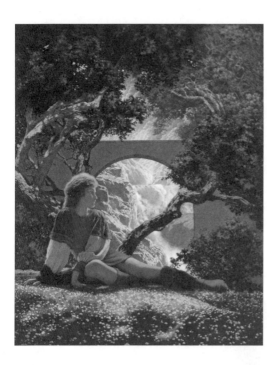

THE PRINCE
1925
From *The Knave of Hearts*
10" X 12" / $225-$275
House of Art

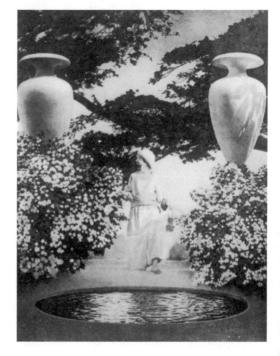

PRINCE AGIB
(THE STORY OF A KING'S SON)
1906
From *The Arabian Nights*
9" X 11" / $130-$150
P.F. Collier & Son

PRINCE CODADAD
1906

From *The Arabian Nights*
9" X 11" / $150-$210
P.F. Collier & Son

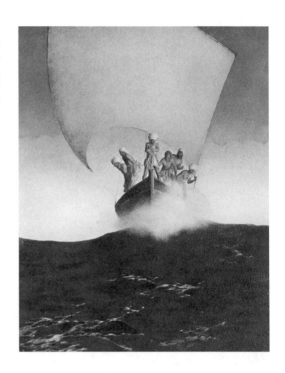

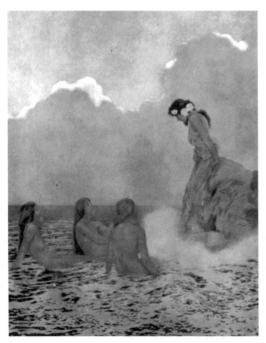

**PROSERPINA AND
THE SEA NYMPHS**
1910

From *A Wonder Book
and Tanglewood Tales*
9 1/4" X 11 1/2" / $145-$210
P.F. Collier & Son

QUEEN GULNARE
1907
From *The Arabian Nights*
9" X 11" / $150-$200
P.F. Collier & Son

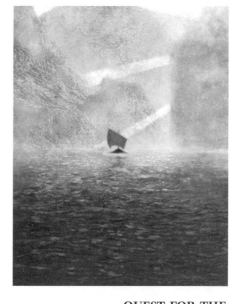

**QUEST FOR THE
GOLDEN FLEECE**
1910
From *A Wonder Book
and Tanglewood Tales*
9 1/4" X 11 1/2" / $100-$200
P.F. Collier & Son

REVERIES or GOLDEN REVERIES
1928
6" X 10" / $125-$150
12" X 15" / $250-$300
House of Art

ROMANCE
1925
From *The Knave of Hearts*
23 1/2" X 14 1/4" / $1100-$1400
House of Art

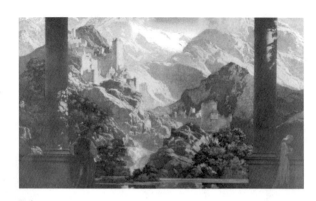

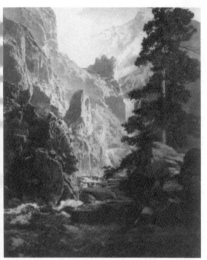

**ROYAL GORGE OF
THE COLORADO**
1923
(Same as "Spirit of Transportation"
without two small trucks on cliff)
16 1/2" X 20" / $500-$600

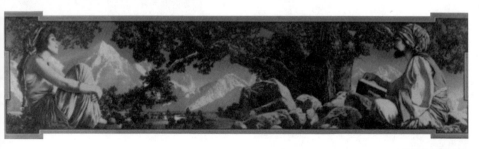

RUBAIYAT
1917
2" X 8 1/2" / $145-$195
3 3/4" X 14 3/4" / $325-$400
7" X 28 1/2" / $650-$800
House of Art

SEARCH FOR THE SINGING TREE
1906

From *The Arabian Nights*
9" X 11" / $130-$150
P.F. Collier & Son

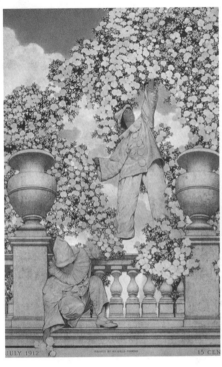

SHOWER OF FRAGRANCE
1912

8 1/2" X 11" / $250-$285
Curtis Publishing Company

SINBAD PLOTS AGAINST THE GIANT
1907

From *The Arabian Nights*
9" X 11" / $155-$185
P.F. Collier & Son

SING A SONG OF SIXPENCE
1911
9" X 21" / $950-$1200
P.F. Collier & Son

SPIRIT OF TRANSPORTATION
1923

(Same as "Royal Gorge of the Colorado"
with addition of two small trucks on cliff)
16 1/2" X 20" / $600-$800

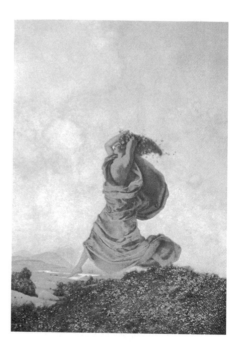

SPRING
1905

From *The Golden Treasury*
of Songs and Lyrics
9 3/4" X 11 3/4" / $130-$160
P.F. Collier & Son

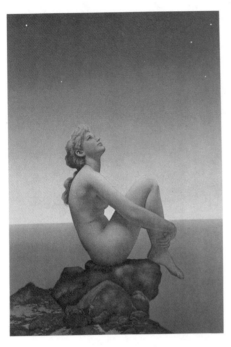

STARS
1927

6" X 10" / $250-$350
10" X 18" / $600-$800
18" X 30" / $1500-$1900
House of Art

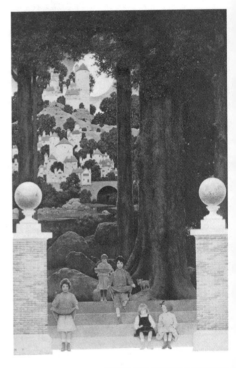

SUGAR-PLUM TREE
1905

From *Poems of Childhood*
11" X 16" / $250-$300
Charles Scribner's Sons

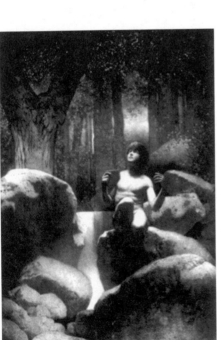

SUMMER
1905

From *The Golden Treasury
of Songs and Lyrics*
11" X 16" / $190-$250
Charles Scribner's Sons

**THE TEMPEST
(AN ODD ANGLE OF THE ISLE)**
1909
7" X 7" / $130-$160
P.F. Collier & Son

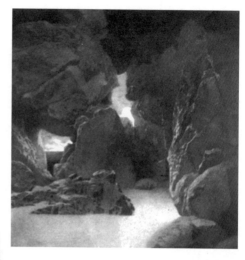

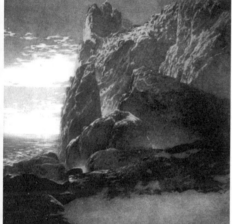

**THE TEMPEST
(AS MORNING STEALS UPON
THE NIGHT)**
1909
7" X 7" / $130-$160
P.F. Collier & Son

**THE TEMPEST
(THE PHOENIX THRONE)**
1909
7" X 7" / $130-$160
P.F. Collier & Son

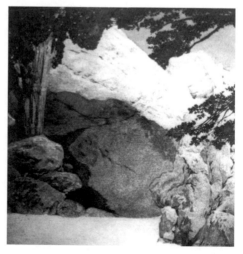

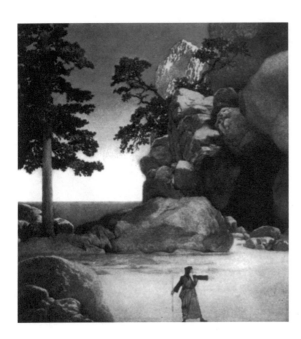

**THE TEMPEST
(PROSPERO AND HIS MAGIC**
1909

7" X 7" / $130-$160
P.F. Collier & Son

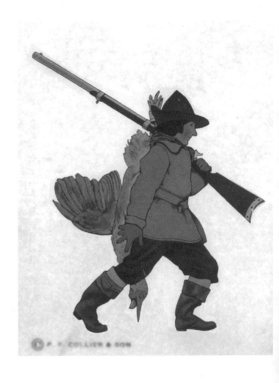

THANKSGIVING
1909

9" X 11" / $225-$275
P.F. Collier & Son

THE THREE SHEPHERDS
or CHRISTMAS
1904
From *The Golden Treasury*
of Songs and Lyrics
11" X 13 1/4" / $240-$280
P.F. Collier & Son

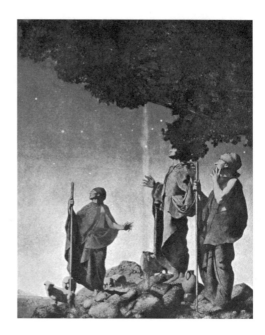

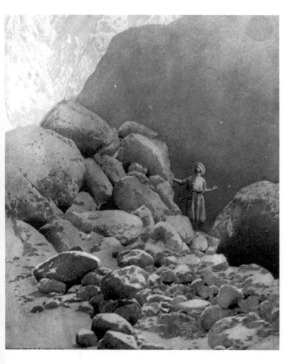

VALLEY OF DIAMONDS
1907
From *The Arabian Nights*
9" X 11" / $130-$160
P.F. Collier & Son

WASSAIL BOWL
1909
3 1/2" X 2 1/2" / $100-$135
P.F. Collier & Son

WHITE BIRCH
1931
9" X 11 1/4" / $125-$150
House of Art

WILD GEESE
1924
11 3/4" X 14 3/4" / $295-$395
House of Art

**WITH TRUMPET AND
DRUM**
1905

From *Poems of Childhood*
11 1/4" X 16 1/2" / $275-$350
Charles Scribner's Sons

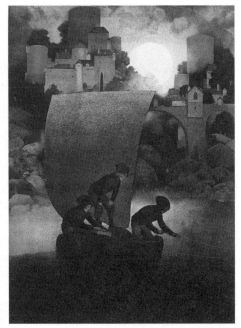

WYNKEN, BLYNKEN, AND NOD
1905

From *Poems of Childhood*
10 1/4" X 14 1/2" / $250-$300
Charles Scribner's Sons

ITALIAN VILLAS AND THEIR GARDENS
1915
The Century Company

PRINTS MEASURE: 5" X 7 3/4" / $60-$80 EACH
WITH MATS: 10 1/2 X 14" / $70-$100 EACH

BOBOLI GARDEN

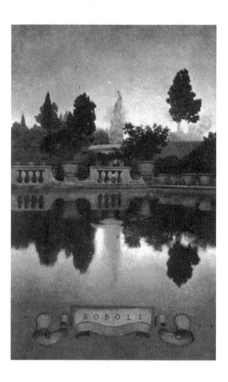

GARDEN OF ISOLA BELLA

POOL OF VILLA D'ESTE

THEATRE AT LA PALAZZINA
SIENA

VILLA CAMPI

VILLA CHIGI

VILLA D'ESTE

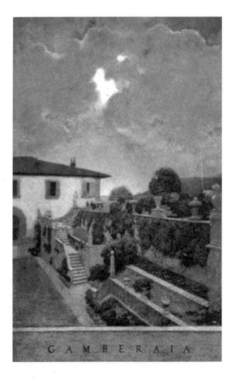

VILLA GAMBERAIA

VILLA GORI

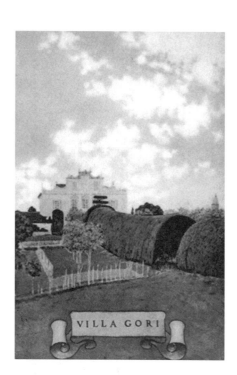

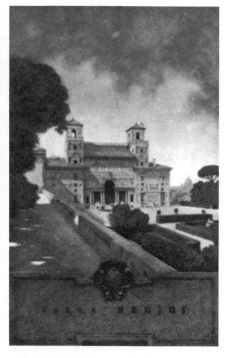

VILLA MEDICI

VILLA ISOLA BELLA

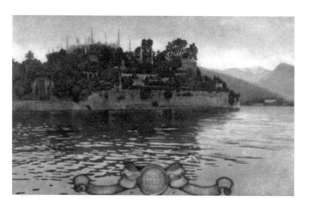

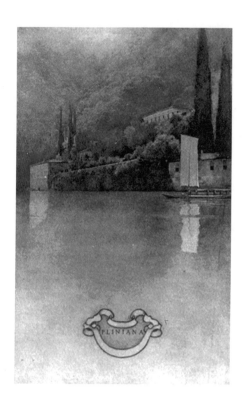

VILLA PLINIANA

VILLA SCASSI

THE
EDISON MAZDA
CALENDARS

"In a long series like these calendars it seems inevitable that in time an artist goes stale. You see it clearly in magazine covers painted by the same artist year after year: his or her work becomes a rubber stamp."

Maxfield Parrish
January 22, 1934

Edison Mazda calendars fall into four main size groups for complete and cropped calendars. The measurements given below are averages from the series. A variance of approximately 1/2" on the small calendars and 1" on the large, can be expected from year to year. Refer to the "Reproductions" chapter for further information about newer reproductions.

MEASUREMENTS
Large complete with full pad: 18" X 37 1/2"
Small complete with full pad: 8 1/2" X 19"
Large cropped: 14 1/2" x 22 1/2"
 (with logo – 1st 7 years)
Small cropped: 6 1/4" X 10 1/2"
 (with logo – 1st 7 years)

Cropped calendar tops without the logo visible (1st 7 years) are valued at 20% less than with the logo visible.

DAWN AND NIGHT IS FLED
1918

Large Complete: $3500-$4000
Small Complete: $2000-$2600
Large Cropped: $2500-$3000
Small Cropped: $900-$1200

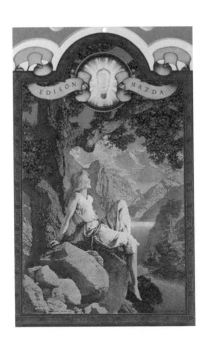

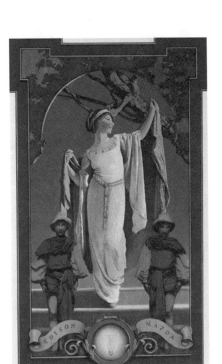

SPIRIT OF THE NIGHT
1919

Large Complete: $3500-$4000
Small Complete: $2000-$2600
Large Cropped: $2500-$3000
Small Cropped: $1200-$1600

PROMETHEUS
1920

Large Complete: $3500-$4000
Small Complete: $2400-$2600
Large Cropped: $2400-$2800
Small Cropped: $1200-$1600

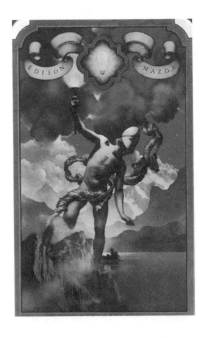

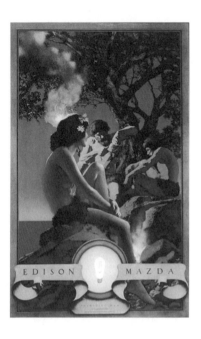

PRIMITIVE MAN

1921

Large Complete: $3200-$3800
Small Complete: $2000-$2400
Large Cropped: $2400-$2800
Small Cropped: $500-$750

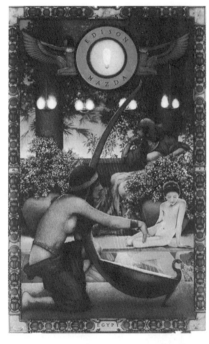

EGYPT

1922

Large Complete: $3200-$3800
Small Complete: $2000-$2400
Large Cropped: $2400-$2800
Small Cropped: $500-$750

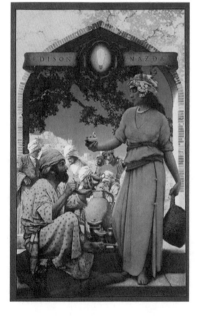

LAMP SELLER OF BAGDAD

1923

Large Complete: $3000-$3600
Small Complete: $1800-$2200
Large Cropped: $2200-$2600
Small Cropped: $500-$750

VENETIAN LAMPLIGHTER
1924

Large Complete: $3000-$3600
Small Complete: $1800-$2200
Large Cropped: $2200-$2400
Small Cropped: $500-$750

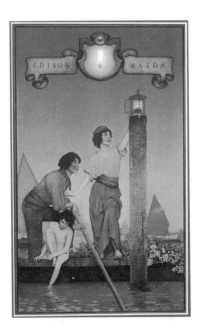

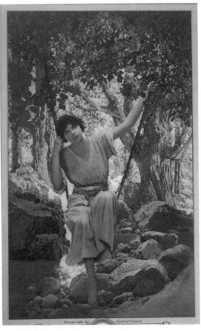

DREAMLIGHT
1925

Large Complete: $2200-$2600
Small Complete: $1400-$1800
Large Cropped: $1600-$2000
Small Cropped: $500-$700

ENCHANTMENT
1926

Large Complete: $2200-$2600
Small Complete: $1400-$1800
Large Cropped: $1600-$2000
Small Cropped: $500-$700

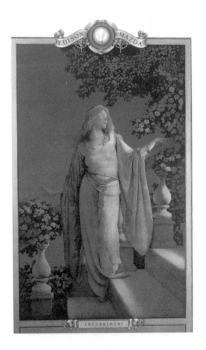

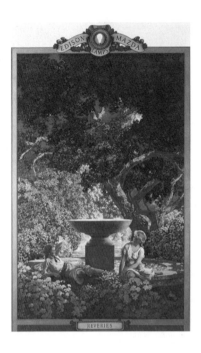

REVERIES
1927

Large Complete: $2100-$2500
Small Complete: $1400-$1800
Large Cropped: $1400-$1800
Small Cropped: $500-$700

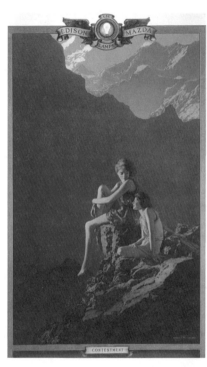

CONTENTMENT
1928

Large Complete: $2100-$2500
Small Complete: $1600-$2000
Large Cropped: $1400-$1800
Small Cropped: $500-$700

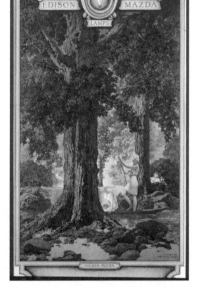

GOLDEN HOURS
1929

Large Complete: $2000-$2400
Small Complete: $1400-$1800
Large Cropped: $1400-$1800
Small Cropped: $400-$500

ECSTASY
1930

Large Complete: $2200-$2600
Small Complete: $1600-$1800
Large Cropped: $1500-$2000
Small Cropped: $500-$750

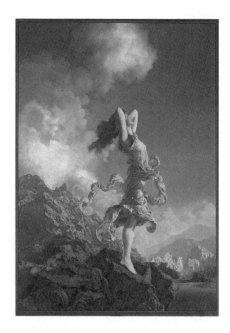

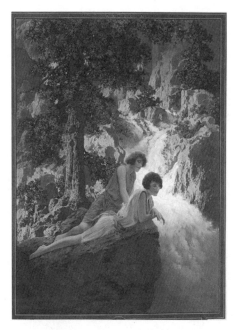

WATERFALL
1931

Large Complete: $2200-$2600
Small Complete: $1600-$1800
Large Cropped: $1500-$2000
Small Cropped: $500-$700

SOLITUDE
1932

Small Complete: $1400-$1600
Small Cropped: $400-$500

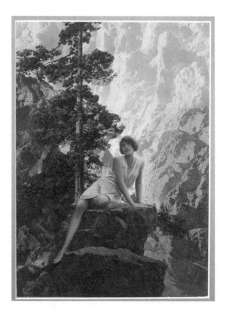

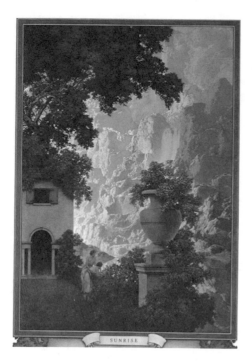

SUNRISE
1933

Large Complete: $2200-$2600
Small Complete: $1600-$1800
Large Cropped: $1500-$2000
Small Cropped: $500-$700

MOONLIGHT
1934

Small Complete: $1400-$1600
Small Cropped: $500-$700

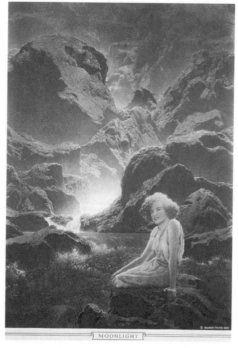

BROWN & BIGELOW
LANDSCAPE CALENDARS

*"I had much rather spend the rest of the time doing
other things, like landscape, which I enjoy much more."*

Maxfield Parrish
December 27, 1929

Brown & Bigelow landscape calendars are mostly referred to by the title given by the publisher. However, there are occasions when the artist's title may be used. Both titles have been listed when known (Parrish titles in parentheses).

The landscapes were printed in a variety of sizes for a diverse market. In recording the artwork, measurements were found to fall into five main groups. These groups, shown below, are the image or cropped size and are the basis for the prices in this chapter. Refer to the "Reproductions" chapter for more information about newer reproductions and their measurements.

MEASUREMENTS

Miniature:	3 1/4" X 4"
X-Small:	4 1/2" X 6"
Small:	8" x 11"
Medium:	11" X 16"
Large:	16 1/2" X 22"
X-Large:	24" X 30"

PEACEFUL VALLEY
(TRANQUILITY)

1936	Complete	Cropped
Miniature	$55-$65	$25-$35
X-Small	$75-$85	$30-$45
Small	$250-$300	$150-$185
Medium	$300-$350	$225-$285
Large	$450-$525	$300-$350
X-Large	$825-$950	$500-$650

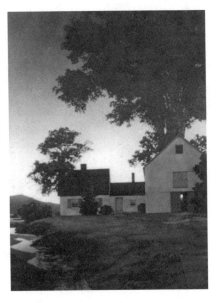

TWILIGHT

1937	Complete	Cropped
Miniature	$50-$55	$25-$35
X-Small	$75-$85	$30-$45
Small	$225-$300	$150-$195
Medium	$325-$375	$210-$250
Large	$450-$525	$285-$325

THE GLEN

1938	Complete	Cropped
Miniature	$60-$65	$25-$35
X-Small	$85-$95	$30-$45
Small	$275-$350	$185-$225
Medium	$375-$450	$250-$300
Large	$625-$725	$395-$445

**EARLY AUTUMN
(AUTUMN BROOK)**

1939	Complete	Cropped
Miniature	$50-$55	$25-$35
X-Small	$80-$100	$30-$45
Small	$225-$295	$165-$200
Medium	$300-$350	$225-$275
Large	$435-$525	$325-$365

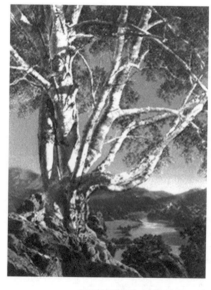

**EVENING SHADOWS
(THE OLD BIRCH TREE)**

1940	Complete	Cropped
Miniature	$65-$70	$25-$35
X-Small	$85-$95	$35-$45
Small	$285-$340	$210-$350
Medium	$410-$475	$295-$365
Large	$585-$685	$400-$450

THE VILLAGE BROOK

1941	Complete	Cropped
Miniature	$50-$60	$25-$35
X-Small	$85-$95	$35-$45
Small	$225-$285	$165-$195
Medium	$325-$400	$245-$285
Large	$495-$575	$350-$395

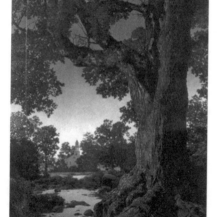

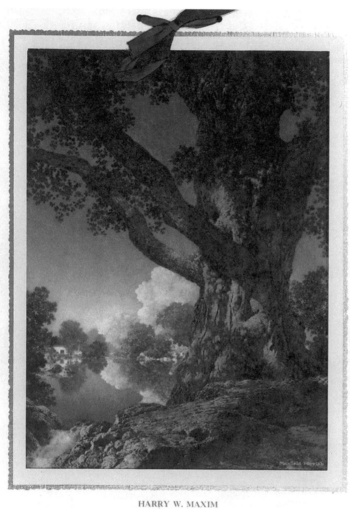

HARRY W. MAXIM
Representing
BROWN & BIGELOW
Remembrance Advertising
518½ Main St. LEWISTON MAINE

SEASON'S 1941 GREETINGS

Example of a complete 1941 calendar

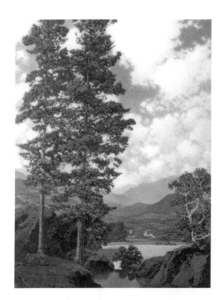

THY TEMPLED HILLS (NEW HAMPSHIRE: THE LAND OF SCENIC SPLENDOR)

1942	Complete	Cropped
Miniature	$50-$60	$20-$30
X-Small	$70-$85	$30-$40
Small	$200-$250	$150-$195
Medium	$325-$395	$225-$275
Large	$450-$525	$325-$375

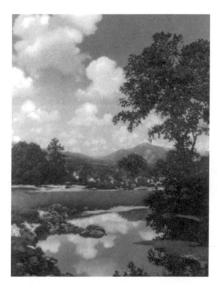

A PERFECT DAY (JUNE SKIES)

1943	Complete	Cropped
Miniature	$50-$60	$20-$30
X-Small	$75-$85	$30-$40
Small	$225-$295	$165-$200
Medium	$325-$385	$250-$300
Large	$475-$575	$325-$400

THY ROCKS AND RILLS (THE OLD MILL)

1944	Complete	Cropped
Miniature	$50-$60	$20-$30
X-Small	$80-$95	$30-$40
Small	$275-$325	$185-$225
Medium	$350-$425	$250-$295
Large	$525-$625	$365-$410

SUNUP
(LITTLE BROOK FARM)

1945	Complete	Cropped
Miniature	$50-$60	$20-$30
X-Small	$65-$75	$30-$40
Small	$225-$285	$175-$200
Medium	$325-$400	$225-$285
Large	$475-$550	$325-$375

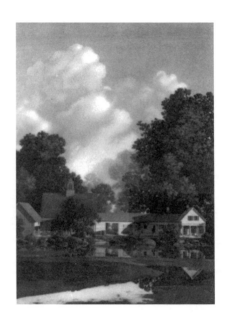

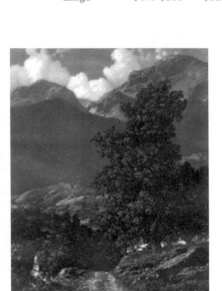

VALLEY OF ENCHANTMENT
(ROAD TO THE VALLEY)

1946	Complete	Cropped
Miniature	$55-$65	$20-$30
X-Small	$75-$85	$30-$45
Small	$265-$300	$195-$225
Medium	$350-$400	$250-$300
Large	$500-$600	$350-$395

EVENING

1947	Complete	Cropped
Miniature	$50-$60	$20-$30
X-Small	$85-$95	$30-$40
Small	$250-$295	$195-$225
Medium	$350-$400	$265-$300
Large	$500-$600	$350-$395

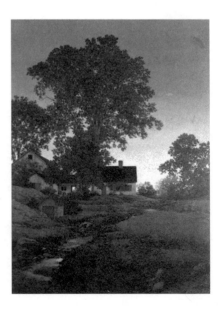

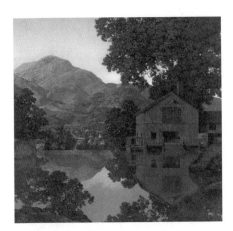

THE MILL POND

1948	Complete	Cropped
Miniature	$60-$75	$25-$30
X-Small	$80-$95	$35-$45
Small	$295-$350	$200-$250
Medium	$400-$495	$300-$350
Large	$625-$725	$400-$450

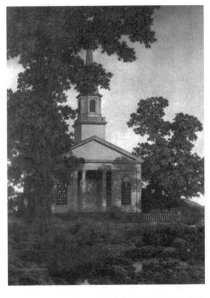

THE VILLAGE CHURCH

1949	Complete	Cropped
Miniature	$50-$60	$25-$30
X-Small	$75-$85	$30-$40
Small	$235-$275	$165-$195
Medium	$325-$395	$225-$275
Large	$475-$575	$325-$385

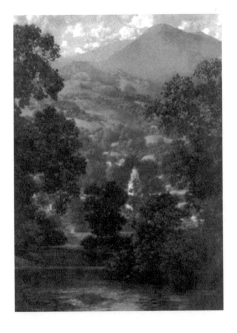

SUNLIT VALLEY

1950	Complete	Cropped
Miniature	$55-$65	$25-$30
X-Small	$75-$90	$30-$40
Small	$250-$325	$185-$225
Medium	$350-$425	$250-$300
Large	$500-$575	$350-$395

DAYBREAK
(HUNT FARM)

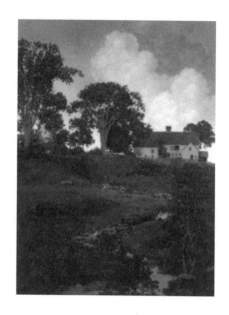

1951	Complete	Cropped
Miniature	$55-$65	$25-$30
X-Small	$80-$95	$35-$40
Small	$265-$325	$200-$225
Medium	$365-$425	$250-$295
Large	$475-$565	$350-$385

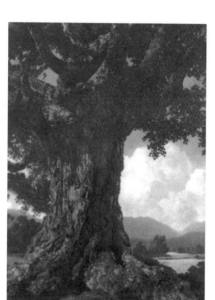

AN ANCIENT TREE

1952	Complete	Cropped
Miniature	$55-$65	$25-$30
X-Small	$75-$85	$30-$40
Small	$265-$325	$195-$225
Medium	$350-$400	$250-$300
Large	$495-$565	$350-$395

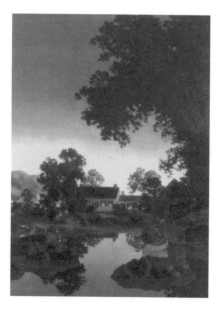

EVENING SHADOWS
(PEACE OF EVENING)

1953	Complete	Cropped
Miniature	$55-$60	$20-$25
X-Small	$80-$95	$30-$40
Small	$265-$325	$195-$225
Medium	$375-$450	$265-$315
Large	$525-$625	$350-$395

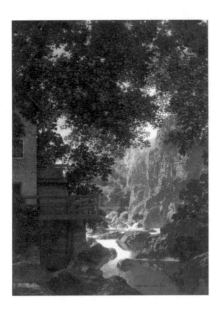

THE OLD GLEN MILL
(GLEN MILL)

1954	Complete	Cropped
Miniature	$65-$75	$25-$35
X-Small	$100-$125	$35-$50
Small	$350-$425	$250-$295
Medium	$450-$525	$325-$385
Large	$650-$750	$425-$500

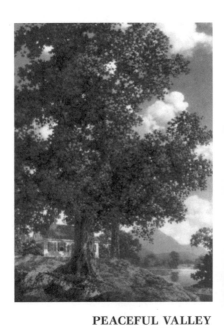

PEACEFUL VALLEY
(HOMESTEAD)

1955	Complete	Cropped
Miniature	$50-$55	$20-$25
X-Small	$70-$85	$30-$40
Small	$250-$295	$185-$210
Medium	$325-$375	$225-$275
Large	$450-$500	$300-$345

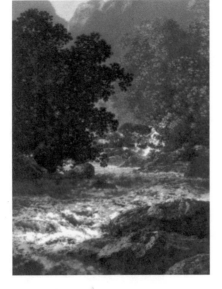

MISTY MORN
(SWIFT-WATER)

1956	Complete	Cropped
Miniature	$55-$60	$25-$30
X-Small	$75-$95	$30-$40
Small	$275-$325	$200-$250
Medium	$375-$425	$275-$300
Large	$550-$600	$350-$395

Example of a complete 1956 calendar

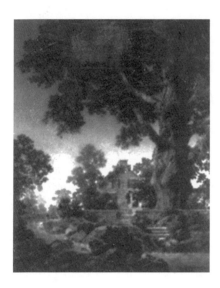

MORNING LIGHT
(THE LITTLE STONE HOUSE)

1957	Complete	Cropped
Miniature	$50-$60	$20-$25
X-Small	$75-$85	$30-$40
Small	$250-$295	$185-$215
Medium	$350-$395	$250-$285
Large	$475-$550	$325-$375

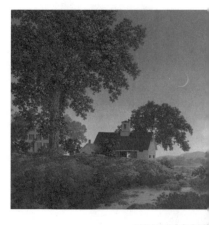

NEW MOON

1958	Complete	Cropped
Miniature	$60-$65	$20-$25
X-Small	$85-$95	$35-$45
Small	$275-$325	$200-$225
Medium	$375-$425	$250-$295
Large	$525-$600	$350-$400

UNDER SUMMER SKIES
(JANION'S MAPLE)

1959	Complete	Cropped
Miniature	$55-$65	$20-$25
X-Small	$75-$85	$30-$40
Small	$275-$295	$200-$225
Medium	$350-$395	$250-$285
Large	$475-$550	$350-$375

SHELTERING OAKS
(A NICE PLACE TO BE)

1960	Complete	Cropped
Miniature	$55-$65	$20-$25
X-Small	$75-$85	$30-$45
Small	$275-$300	$200-$225
Medium	$350-$400	$275-$300
Large	$500-$575	$350-$375

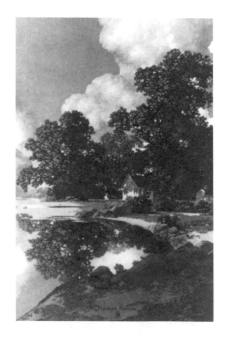

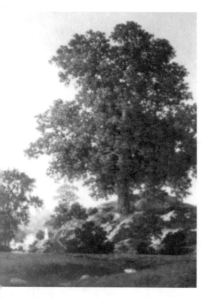

TWILIGHT
(THE WHITE OAK)

1961	Complete	Cropped
Miniature	$50-$55	$20-$25
X-Small	$65-$80	$30-$40
Small	$240-$275	$175-$200
Medium	$300-$350	$225-$250
Large	$425-$475	$300-$350

QUIET SOLITUDE
(CASCADES)

1962	Complete	Cropped
Miniature	$55-$65	$20-$25
X-Small	$75-$85	$30-$45
Small	$275-$325	$200-$225
Medium	$350-$400	$275-$300
Large	$525-$600	$365-$395

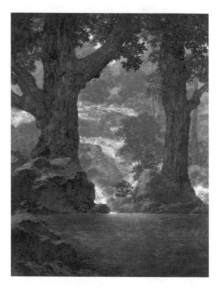

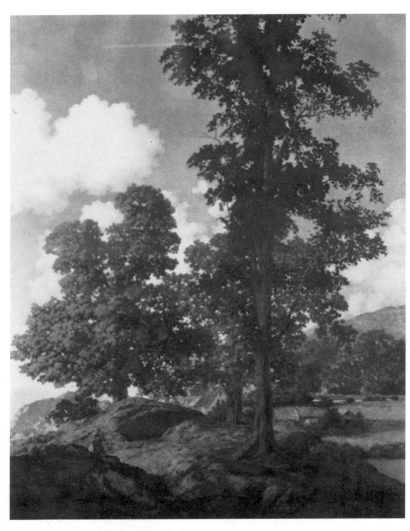

PEACEFUL COUNTRY

1963	Complete	Cropped
Miniature	$50-$60	$20-$25
X-Small	$75-$85	$30-$40
Small	$250-$295	$195-$225
Medium	$325-$395	$250-$295
Large	$525-$575	$350-$400

BROWN & BIGELOW
WINTER CALENDARS

"An artist is best, needless to say, in the things he likes best. I am most happy in out-of-door things, subjects in nature's own light: fanciful things, in color and design, belonging to no particular time or place."

Maxfield Parrish
January 22, 1934

Brown & Bigelow winter calendars are
mostly referred to by the title given by the
publisher. However, there are occasions when
the artist's title may be used. Both titles have
been listed when known (Parrish titles in
parentheses).

The winter calendars were printed in odd
sizes from year to year ranging from 8 1/2" X 11"
to 12 1/2" X 17". Refer to the "Reproductions"
chapter for more information about newer
reproductions and their measurements.

WINTER TWILIGHT
1941
$225-$300

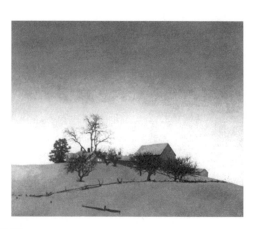

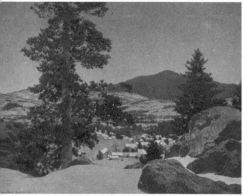

**SILENT NIGHT
(WINTER NIGHT)**
1942
$200-$250

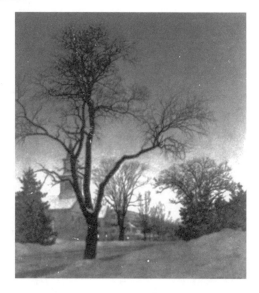

**AT CLOSE OF DAY
(PLAINFIELD N.H. CHURCH
AT DUSK)**
1943
$225-$275

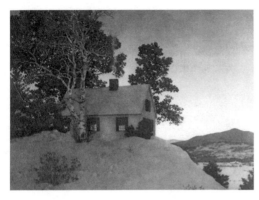

EVENTIDE
1944
$285-$350

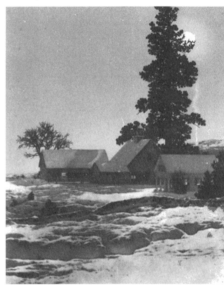

**LIGHTS OF HOME or
SILENT NIGHT**
1945
$285-$350

**THE PATH TO HOME
(ACROSS THE VALLEY)**
1946
$250-$300

**PEACE AT TWILIGHT
(LULL BROOK)**
1947
$225-$295

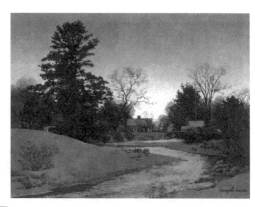

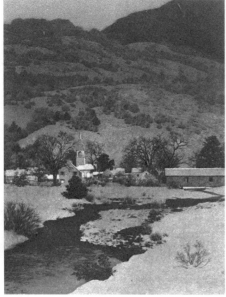

**CHRISTMAS EVE
(DEEP VALLEY)**
1948
$235-$300

CHRISTMAS MORNING
1949
$250-$325

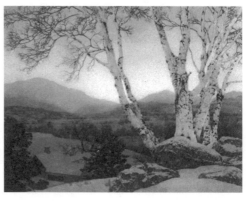

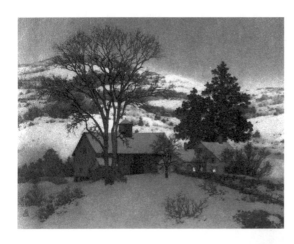

**A NEW DAY
(AFTERGLOW)**
1950
$225-$295

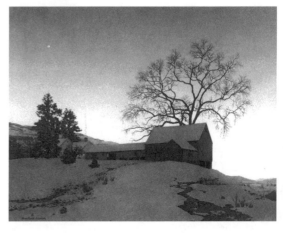

THE TWILIGHT HOUR
1951
$210-$275

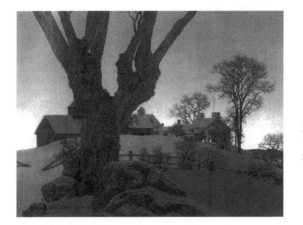

LIGHTS OF WELCOME
1952
$225-$285

PEACEFUL NIGHT
(CHURCH AT NORWICH)
1953
$225-$275

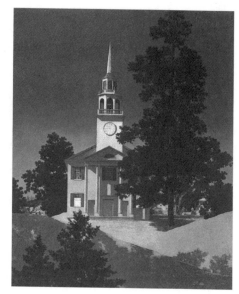

WHEN DAY IS DAWNING
(WINTER SUNRISE)
1954
$235-$295

SUNRISE
(WHITE BIRCHES IN A GLOW)
1955
$235-$300

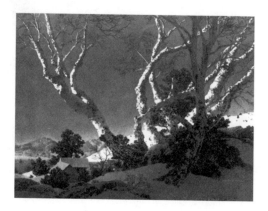

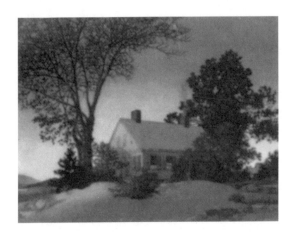

EVENING
1956
$250-$300

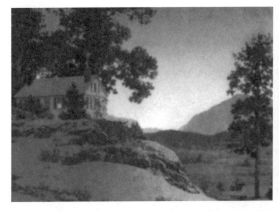

**AT CLOSE OF DAY
(NORWICH, VERMONT)**
1957
$250-$300

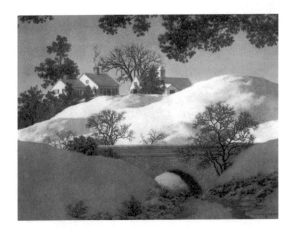

**SUNLIGHT
(WINTER SUNSHINE)**
1958
$275-$350

**PEACE OF EVENING
(DINGLETON FARM)**
1959
$250-$285

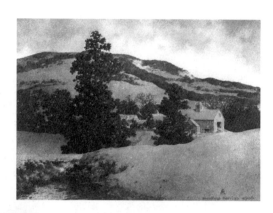

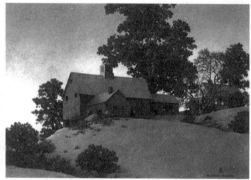

**TWILIGHT TIME
(FREEMAN FARM)**
1960
$250-$285

DAYBREAK
1961
$250-$295

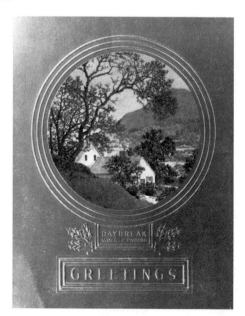

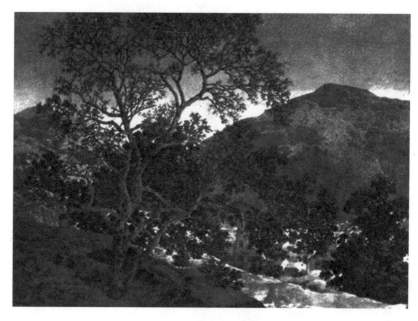

EVENING SHADOWS
1962
$250-$300

ILLUSTRATED BOOKS

"I'd rather paint two pictures than try to tell WHY I painted one."

Maxfield Parrish
June 4, 1936

AMERICAN ART BY AMERICAN ARTISTS
1898-1914 / $110-$165 Each

"One Hundred Favorite Paintings"
A series of editions containing color plates
from *The Arabian Nights* and *A Wonder Book
and Tanglewood Tales*
Plate sizes average 12" X 16"
P.F. Collier & Son

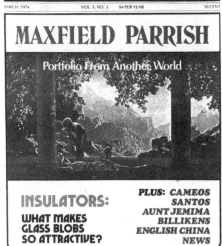

AMERICAN HERITAGE
1970, December / $25-$45

AMERICAN PICTURES AND THEIR PAINTERS
1917 / $50-$70

Author: Lorinda M. Bryant
Three illustrations in black and white from
the Florentine Fete Murals
John Lane Company

AMERICAN COLLECTOR
1974, March / $20-$30

THE ANNUAL OF ADVERTISING ART IN THE UNITED STATES
1921 Containing five illustrations
in black and white / $65-$85
1923 Containing two illustrations
in black and white / $55-$65
1924 Containing three illustrations
in black and white / $55-$75
1925 Containing three illustrations
in black and white / $55-$75

THE ARABIAN NIGHTS, THEIR BEST-KNOWN TALES
1909

Editors: Kate Wiggin & Nora Smith
Containing twelve illustrations in color
Charles Scribner's Sons
$185-$245

Later versions contain nine illustrations in color
$125-$165

BOLANYO
1897 / $160-$200

Author: Opie Read
Cover in two color
Back cover is same as front
Way & Williams

THE CHILDREN'S BOOK
1907 / $85-$110

Editor: Horace E. Scudder
Cover in color
Houghton Mifflin Company

DREAM DAYS
1898 / $150-$200

Author: Kenneth Grahame
Ten illustrations in black and white
Three tailpieces in black and white
John Lane Company
Second edition 1902 / $90-$110

THE EMERALD STORY BOOK
1917 / $100-$145

Author: Ada and Eleanor Skinner
Frontispiece in color
Duffield & Company

FREE TO SERVE
1897 / $110-$150

Author: Emma Rayner
Cover in color
Copeland & Day

**THE GARDEN OF YEARS AND
OTHER POEMS**
1904 / $75-$95

Author: Guy Wetmore Carryl
Frontispiece in color
G.P. Putnam's Sons

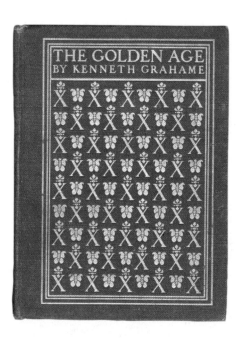

THE GOLDEN AGE
1899 / $150-$200

Author: Kenneth Grahame
Nineteen illustrations in black and white
Thirteen tailpieces in black and white
John Lane Company

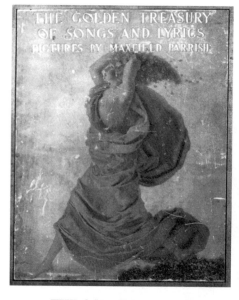

**THE GOLDEN TREASURY OF
SONGS AND LYRICS**
1911 / $200-$285

Author: Francis Turner Palgrave
Eight illustrations in color
Duffield & Company
Second edition 1941 / $85-$100
(Contains only four illustrations in color)

**GRAPHIC ARTS AND
CRAFTS YEARBOOK**
1907 / $45-$65

Editor: Joseph Meadon
Two illustrations in color
Republican Publishing Company

**THE HISTORY AND IDEALS OF
AMERICAN ART**
1931 / $25-$40

Author: Eugene Neuhaus
Two illustrations in black and white
Stanford University Press

ITALIAN VILLAS AND THEIR GARDENS
1904 / $250-$350

Author: Edith Wharton
Fifteen illustrations in color
Eleven illustrations in black and white
The Century Company

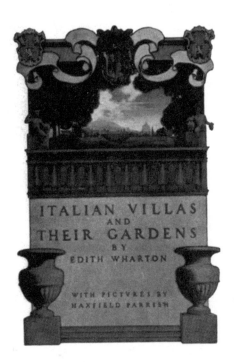

THE JUNIOR CLASSICS
1912 Vol. II / $40-$50

Editor: William Patten
Frontispiece in color
P.F. Collier & Son

THE JUNIOR CLASSICS
1912 Vol. III / $55-$65

Editor: William Patten
One color frontispiece
Three illustrations in black and white
P.F. Collier & Son

KING ALBERT'S BOOK
1914 / $100-$125

Editor: The Daily Telegraph
Illustration in color "Dies Irae"
Hearst's International Library Company

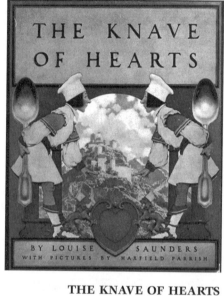

THE KNAVE OF HEARTS
1925

Author: Louise Saunders
Twenty-three illustrations in color
Charles Scribner's Sons
Hardbound in box / $1800-$2000
Hardbound / $1400-$1600
Spiral / $700-$900
(Spiral did not have
cover lining "Romance")

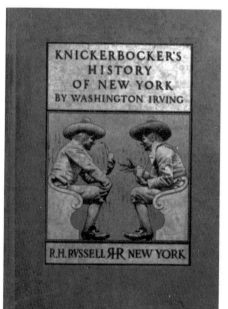

**KNICKERBOCKER'S HISTORY
OF NEW YORK**
1900 / $285-$375

Author: Washington Irving
Eight illustrations in black and white
R.H. Russell
Second edition / $150-$175

LURE OF THE GARDEN
1911 / $65-$85

Author: Hildegarde Hawthorne
Illustration in color
The Century Company

MAKE BELIEVE WORLD OF SUE LEWIN
1978 / $65-$75
Author: L.A. Ferry

MAXFIELD PARRISH
1973 / $75-$85

Author: Coy Ludwig
Sixty-four illustrations in color
One hundred two illustrations in
black and white
Watson-Guptill Publications
Second edition 1974 / $50-$60

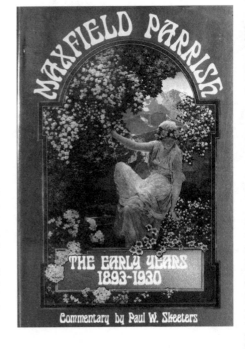

MAXFIELD PARRISH
THE EARLY YEARS
1973 / $275-$350

Author: Paul W. Skeeters
One hundred seventy illustrations in color
Sixty illustrations in black and white
Nash Publishing
Also published by Chartwell Books
with a lesser color and image quality
Second edition 1974 / $250-$270

**MAXFIELD PARRISH
THE EARLY YEARS
(JAPANESE VERSION)**
1974 / $75-$100

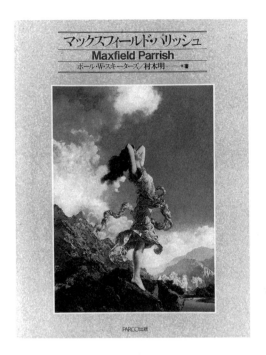

MAXFIELD PARRISH
"IN THE BEGINNING"

**MAXFIELD PARRISH
"IN THE BEGINNING"**
1976 / $85-$100

Author: Virginia Hunt Reed
Imperial Printers

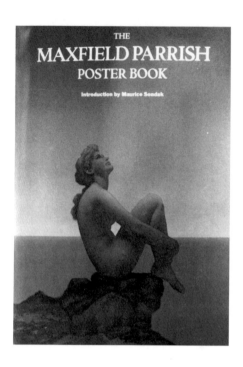

**MAXFIELD PARRISH
POSTER BOOK**
1974 / $35-$65

Introduction: Maurice Sendak
Twenty-three illustrations in color
Bruce Harris, Publisher
Numerous reprints exist

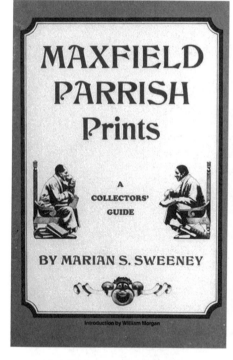

MAXFIELD PARRISH PRINTS
1974 / $20-$25

Author: Marian S. Sweeney
Twenty-one illustrations in black and white
William L. Bauhan, Publisher

MODERN ILLUSTRATING
1930 / $35-$45

Editors: Charles Bartholomew & Joseph Almars
Two illustrations in black and white
Federal Schools Publishing

MOTHER GOOSE IN PROSE
1897 / $1800-$2200

Author: L. Frank Baum
Thirteen illustrations in black and white
Twenty-two headpieces in black and white
Way and Williams
Numerous reprints exist

MURAL PAINTING IN AMERICA
1913 / $30-$50

Author: Edwin H. Blashfield
Two illustrations in black and white
Charles Scribner's Sons

PETERKIN
1912 / $75-$100

Author: Gabrielle E. Jackson
Cover and frontispiece (the same) in color
Duffield & Company

POEMS OF CHILDHOOD
1904 / $185-$245

Author: Eugene Field
Nine illustrations in color
Charles Scribner's Sons

POSTERS: A CRITICAL STUDY OF THE DEVELOPMENT OF POSTER DESIGN
1913 / $90-$125
Author: Charles Matlack Price
Two illustrations in color
Three illustrations in black and white
George W. Bricka, Publisher

POSTERS IN MINIATURE
1897 / $100-$130
Two illustrations in black and white
R.H. Russell

ROMANTIC AMERICA
1913 / $50-$60
Author: Robert Haven Schauffler
Frontispiece in color
The Century Company

THE RUBY STORY BOOK
1921 / $90-$130
Frontispiece in color
Duffield & Company

THE SAPPHIRE STORY BOOK
1919 / $100-$130
Frontispiece in color
Duffield & Company

SONG OF HIAWATHA
1912 / $100-$120
Author: Henry Wadsworth Longfellow
Cover in color
Houghton Mifflin Company

THIRTY FAVORITE PAINTINGS
1908 / $175-$225
Illustration in color "Pierrot's Serenade"
P.F. Collier & Son

THE TOPAZ STORY BOOK
1917 / $100-$125
Author: Ada and Eleanor Skinner
Frontispiece in color
Duffield & Company

TROUBADOUR TALES
1903 / $60-$80
Author: Evaleen Stein
Frontispiece in color
Bobbs-Merrill Company
Second edition 1929 / $25-$40

THE TURQUOISE CUP AND THE DESERT
1903 / $60-$75
Author: Arthur Cosslett Smith
Frontispiece in color
Two headpieces in black and white
Charles Scribner's Sons
Second edition 1910 / $30-$50

THE TURQUOISE STORY BOOK
1916 / $100-$130
Author: Ada and Eleanor Skinner
Frontispiece in color
Duffield & Company

WATER COLOUR RENDERING SUGGESTIONS
1917 / $200- $250
Seven illustrations in black and white
J.H. Jansen, Printing Co.

WHIST REFERENCE BOOK
1897 / $165-$200

Author: Butler
Title page in color
John C. Yorston and Company
"Ye Royall Recepcioun"

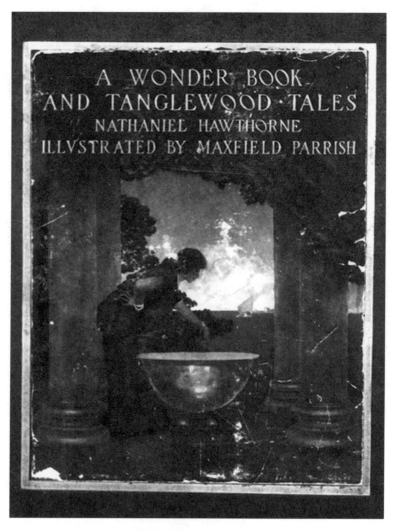

**A WONDER BOOK AND
TANGLEWOOD TALES**
1910 / $225-$265

Author: Nathaniel Hawthorne
Ten illustrations in color
Duffield & Company

ILLUSTRATED MAGAZINES

"I would rather have a tooth pulled than sit for a picture."

Maxfield Parrish
February 12, 1898

Magazines generally fall into two main groups: newstand issues, which were sold flat; and subscription issues which were often times mailed with an address label affixed to the front cover.

The subscription issues ususally suffered from a verticle crease through the center of the magazine.

Where a price is listed for a magazine cover in this chapter, it means just that - for the cover only.

Add a price increase of 35% for complete newstand issues and a price increase of 25% for complete subscription issues.

AGRICULTURAL LEADER'S DIGEST
1934, November / $45-$50
Cover in color

AMERICAN ARTIST
1973, October / $25-$35
Cover in color

AMERICAN MAGAZINE
1918, September / $75-$95
Back cover advertisement in color for Djer-Kiss Cosmetics

AMERICAN MAGAZINE
1921, May / $35-$40
Illustration in color "Be My Valentine"

AMERICAN MAGAZINE
1921, July / $30-$35
Advertisement in sepia for Hires Root Beer

THE AMERICAN MAGAZINE OF ART
1918, January / $50-$60
"The Art of Maxfield Parrish" Containing sixteen black and white illustrations of Parrish-illustrated books, magazine covers, a Florentine Fete mural, and a Fisk Tire advertisement

AMERICAN MONTHLY REVIEW OF REVIEWS
1900, December / $15-$20
Illustration in black and white "Father Knickerbocker"

AMERICAN MONTHLY REVIEW OF REVIEWS
1918, February / $95-$125
Advertisement in color "And Night is Fled" (See "E.M. Calendars")

ANTIQUES
1936 / $10-$15
Illustration in black and white "Daybreak"

ANTIQUES
1979 / $20-$25
Cover in color "Thy Templed
Hills"

ANTIQUE TRADER
1978, May 31 / $10-$15
Cover in color "Daybreak"

**ARCHITECTURAL LEAGUE OF
NEW YORK YEARBOOK**
1914 / $15-$20
Two illustrations in black and white
from the Florentine Fete murals

**ARCHITECTURAL LEAGUE OF
NEW YORK YEARBOOK**
1917 / $25-$30
Two illustrations in black and white of a
mural for the studio of Mrs. Payne Whitney
One illustration in black and white from
the Florentine Fete murals

ARCHITECTURAL RECORD
1907, January / $15-$20
Illustration in black and white
"Old King Cole" (St. Regis)

ART INTERCHANGE
1896, June / $40-$50

Two illustrations in black and white of two prize-winning entries in poster contest, one for Pope Manufacturing, one for *Century* Magazine

ART JOURNAL
1903, June / $10-$15

Illustration in black and white "The Reluctant Dragon"

THE ARTIST
1898 / $45-$55

Two illustrations in black and white of posters, one from *Century* Magazine, August 1897, and one from *Scribner's*, August 1897

ARTS AND DECORATION
1923, October / $5-$10
Illustration in black and white "Daybreak"

ATLANTIC MONTHLY
1921, June / $45-$55

Advertisement in color for Hires Root Beer

ATLANTIC MONTHLY
1922, February / $45-$55

Advertisement in color for Jello "The King and Queen Might Eat Thereof"

ATLANTIC MONTHLY
1925, December / $15-$20

Illustration in black and white "Potato Peelers"

BOOK BUYER
1897, Christmas / $145-$165

Cover in color

BOOK BUYER
1898, April / $35-$40

Five illustrations in black and white

BOOK BUYER
1898, December / $145-$165
Cover in color

BOOK BUYER
1899, April / $125-$150
Cover in color

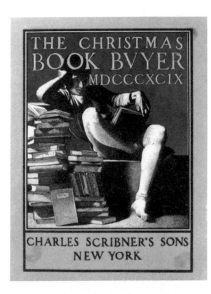

BOOK BUYER
1899, December / $125-$150
Cover in black and white

THE BOOKMAN
1899, February / $20-$25
Illustration in black and white
"The Three Wise Men of Gotham"

THE BOOKMAN
1900, September / $20-$25
Illustration in black and white "Saint
Nicholas"

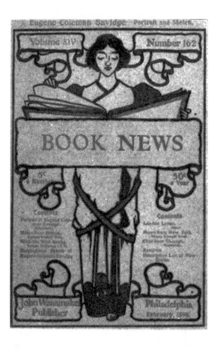

BOOK NEWS
1895, February / $90-$100
Cover in black and white
Also same cover design for
October-December 1895 and
January-February 1896

BOOK NEWS
1896, March-September / $85-$95
Covers in color all sharing the same desig
of a woman bending over reading a book

BOOK NEWS
1897, March-April / $75-$85
Cover designs same as previous, but with
different colors

BOOK NEWS
1897, June / $90-$120

Cover in black and white with light blue sky, woman reading a book with castles in the background

BRADLEY, HIS BOOK
1896, November / $65-$100

Four illustrations in black and white which include a poster for the Philadelphia Horse Show Association, a program cover for the Mask and Wig Club, a frontispiece and tailpiece

BRUSH AND PENCIL
1898, January / $50-$60

Three illustrations in black and white "The Man in the Moon," "Jack Horner," and "The Wond'rous Wise Man"

CANADIAN HOME AND GARDEN
1927, May / $20-$25

Advertisement in black and white

CENTURY MAGAZINE
1898, December / $30-$35

Double frontispiece in sepia

CENTURY MAGAZINE
1899, December / $20-$25
Illustration in black and white
"A Hill Prayer"
Also two page decorations

CENTURY MAGAZINE
1900, July / $15-$20
Illustration in black and white

CENTURY MAGAZINE
1900, December / $40-$50
Advertisement in black and white
for Fisk Tires "The Magic Circle"

CENTURY MAGAZINE
1901, January / $20-$30
Illustration in black and white
Also three page decorations
Two page decorations shown here

CENTURY MAGAZINE
1901, December / $40-$45

Four illustrations in black and white
Also one black and white bookplate

CENTURY MAGAZINE
1902, May / $50-$60

Two illustrations in color
Four illustrations in black and white from
"The Great Southwest"

CENTURY MAGAZINE
1902, June / $30-$35

Five illustrations in black and white from
"The Great Southwest"

CENTURY MAGAZINE
1902, July / $25-$30

Four illustrations in black and white from
"The Great Southwest"

CENTURY MAGAZINE
1902, August / $25-$30

Four illustrations in black and white from
"The Great Southwest"

CENTURY MAGAZINE
1902, November / $75-$110

Seven illustrations in color from
"The Great Southwest"

CENTURY MAGAZINE
1903, November / $35-$45

Four illustrations in color and one
illustration in black and white from
Italian Villas and Their Gardens

CENTURY MAGAZINE
1903, December / $25-$30

Three illustrations in color from *Italian
Villas and Their Gardens*

CENTURY MAGAZINE
1904, February / $25-$35

Two illustrations in color and three
illustrations in black and white from
Italian Villas and Their Gardens, also
includes a headpiece

CENTURY MAGAZINE
1904, April / $25-$30

Two illustrations in color and two
 illustrations in black and white from
Italian Villas and Their Gardens

CENTURY MAGAZINE
1904, August / $35-$40

Four illustrations in color from *Italian
Villas and Their Gardens*

CENTURY MAGAZINE
1904, October / $25-$30

One illustration in color and five
illustrations in black and white from
Italian Villas and Their Gardens, also
includes the title page

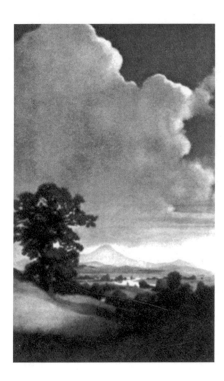

CENTURY MAGAZINE
1904, November / $20-$25

Illustration in color
"Ode to Autumn"

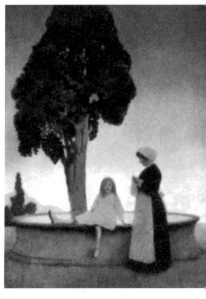

CENTURY MAGAZINE
1904, December / $25-$35

Illustration in color "I Am Sick
of Being a Princess"

CENTURY MAGAZINE
1905, March / $15-$20

Illustration in black and white
"A Journey Through Sunny Provence"

CENTURY MAGAZINE
1905, October / $45-$55

Frontispiece in color "The Sandman"

CENTURY MAGAZINE
1910, August / $25-$35

Frontispiece in color

CENTURY MAGAZINE
1910, November / $10-$15

Illustration in black and white

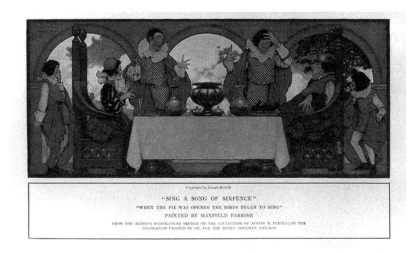

CENTURY MAGAZINE
1911, February / $65-$75
Illustration in color "Sing a Song of Sixpence"

CENTURY MAGAZINE
1911, April / $45-$60
Illustration in color "Quod Erat
Demonstrandum" (Proving It By the Book)

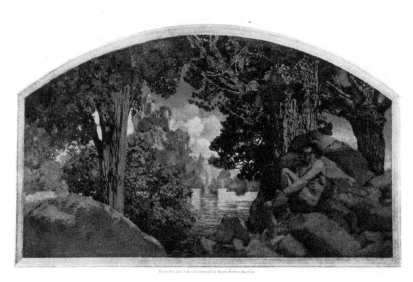

CENTURY MAGAZINE
1912, April / $35-$50
Frontispiece in color "Dream Castle in the Sky"

CENTURY MAGAZINE
1912, July / $55-$75

Five illustrations in black and white
and ten paper cut outs and illustrations

CENTURY MAGAZINE
1912, August / $50-$65

Six illustrations in black and white from t
Florentine Fete murals

CENTURY MAGAZINE
1915, December / $45-$55

Frontispiece in color "Pipe
Night at the Players"

CENTURY MAGAZINE
1917, August / $75-$90

Cover in color

CENTURY MAGAZINE
1918, December / $45-$55

Advertisement in color for Community Pla

CENTURY MAGAZINE
1921, June / $45-$65
Advertisement in color for
Hires Root Beer

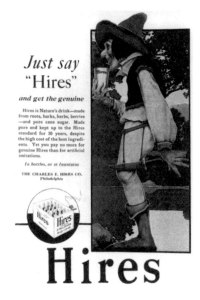

CENTURY MAGAZINE
1921, July / $45-$65
Advertisement in color for
Hires Root Beer

CHRISTIAN HERALD
1919, March / $80-$90
Advertisement in color for Ferry Seeds
"Peter, Peter" (See "Posters")

COLLIER'S MAGAZINE
1904, April 30 / $10-$15
Headpiece in black and white

COLLIER'S MAGAZINE
1904, June 25 / $10-$15
Headpiece in black and white

COLLIER'S MAGAZINE
1904, October 29 / $5-$10
Headpiece in black and white

COLLIER'S MAGAZINE
1904, December 3 / $85-$100
Cover in color "The Three Shepherds"
(See "Prints")

COLLIER'S MAGAZINE
1905, January 7 / $85-$100
Cover in color "Father Time"

COLLIER'S MAGAZINE
1905, January 21 / $5-$10
Headpiece in black and white

COLLIER'S MAGAZINE
1905, February 11 / $35-$45
Cover in color
Also a headpiece in black and white

COLLIER'S MAGAZINE
1905, March 4 / $35-$50
Cover in color, frame around a photograph
of President Roosevelt

COLLIER'S MAGAZINE
1905, April 8 / $5-$10
Headpiece in black and white

COLLIER'S MAGAZINE
1905, April 15 / $85-$95
Cover in color "Easter"
(See "Prints")

COLLIER'S MAGAZINE
1905, May 6 / $75-$90
Cover in color "Spring"
(See "Prints")

COLLIER'S MAGAZINE
1905, May 20 and June 3 / $35-$45
Permanent cover design in color

COLLIER'S MAGAZINE
1905, July 1 / $85-$100
Cover in color

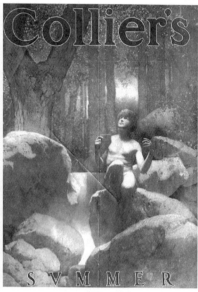

COLLIER'S MAGAZINE
1905, July 22 / $85-$100
Cover in color "Summer"

COLLIER'S MAGAZINE
1905, August 5 / $25-$45
Permanent cover design in color

COLLIER'S MAGAZINE
1905, September 23 / $65-$85
Cover in color "Harvest"
(See "Prints")

COLLIER'S MAGAZINE
1905, October 14 / $135-$175
Cover in color "Hiawatha"

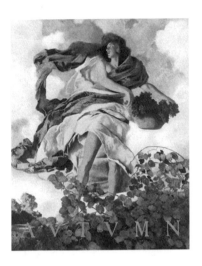

COLLIER'S MAGAZINE
1905, October 28 / $95-$135
Cover in color "Autumn"

COLLIER'S MAGAZINE
1905, November 4 / $35-$45
Permanent cover design in color

COLLIER'S MAGAZINE
1905, December 2 / $35-$45
Permanent cover design in color

COLLIER'S MAGAZINE
1905, November 18 / $85-$100
Cover in color
"Tramp's Thanksgiving"

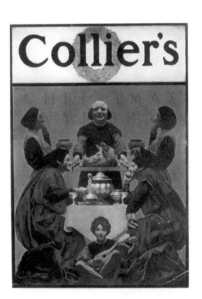

COLLIER'S MAGAZINE
1905, December 16 / $85-$100
Cover in color
"The Boar's Head"

COLLIER'S MAGAZINE
1906, January 6 / $85-$100
Cover in color

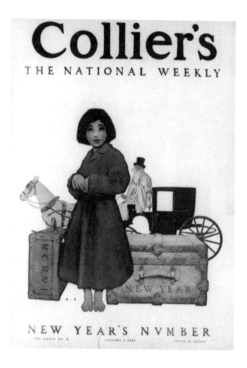

COLLIER'S MAGAZINE
1906, February 3 / $35-$45
Permanent cover design in color

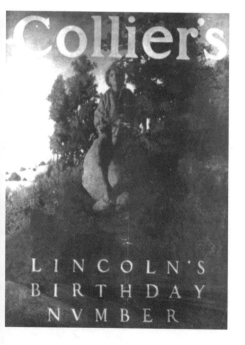

COLLIER'S MAGAZINE
1906, February 10 / $75-$95
Cover in color

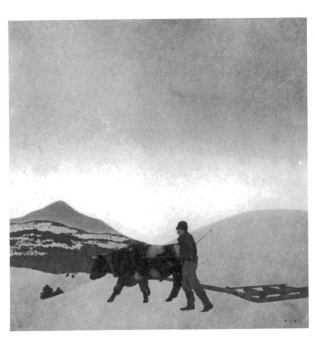

COLLIER'S MAGAZINE
1906, March 10 / $75-$95
Cover in color "Winter"

COLLIER'S MAGAZINE
1906, April 7 / $45-$55

Frontispiece in color "The Fisherman
and the Genie"
(See "Prints")

COLLIER'S MAGAZINE
1906, April 14 / $35-$45

Permanent cover design in color

COLLIER'S MAGAZINE
1906, April 21 / $5-$10

Headpiece in black and white

COLLIER'S MAGAZINE
1906, May 19 / $85-$95

Cover in color "Milking Time"

COLLIER'S MAGAZINE
1906, June 23 / $85-$100
Cover in color "The Gardener"

COLLIER'S MAGAZINE
1906, July 7 / $100-$125
Cover in color

COLLIER'S MAGAZINE
1906, July 21 / $85-$100
Cover in color "The Swing"

COLLIER'S MAGAZINE
1906, September 1 / $40-$50
Frontispiece in color
Also four headpieces in black and white

COLLIER'S MAGAZINE
1906, October 13 / $35-$45
Frontispiece in color "Prince Agib"
(See "Prints")

COLLIER'S MAGAZINE
1906, October 27 / $5-$10
Headpiece and tailpiece in black and white

COLLIER'S MAGAZINE
1906, November 3 / $35-$45
Frontispiece in color "Cassim in the Cave"
(See "Prints")

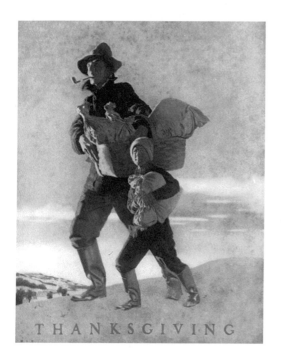

COLLIER'S MAGAZINE
1906, November 17 / $95-$125
Cover in color

COLLIER'S MAGAZINE
1906, December 1 / $45-$60

Frontispiece in color
"Search for the Singing Tree"
(See "Prints")

COLLIER'S MAGAZINE
1906, December 15 / $35-$45

Frontispiece in color
Also a black and white page decoration

COLLIER'S MAGAZINE
1906, December 22 / $25-$35

1907 Calendar advertisement in black and
white showing two illustrations, "Summer"
and *Collier's* cover from January 7, 1905

COLLIER'S MAGAZINE
1907, January 5 / $85-$100
Cover in color

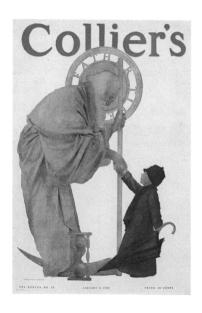

COLLIER'S MAGAZINE
1907, January 19 / $35-$45
Permanent cover design in color

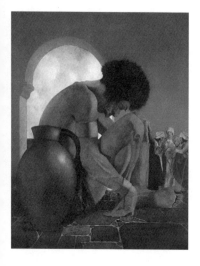

COLLIER'S MAGAZINE
1907, February 9 / $45-$60

Frontispiece in color
"Sinbad Plots Against the Giant"
(See "Prints")

COLLIER'S MAGAZINE
1907, March 16 / $35-$45

Frontispiece in color "The City of Brass"
(See "Prints")

COLLIER'S MAGAZINE
1907, March 30 / $15-$20

Two page decorations

COLLIER'S MAGAZINE
1907, May 18 / $35-$45

Frontispiece in color
"King of the Black Isles"
(See "Prints")

COLLIER'S MAGAZINE
1907, June 22 / $35-$45

Frontispiece in color
"Aladdin and the Wonderful Lamp"
(See "Prints")

COLLIER'S MAGAZINE
1907, August 3 / $35-$45

Frontispiece in color "Queen Gulnare"
(See "Prints")

COLLIER'S MAGAZINE
1907, September 7 / $35-$45

Frontispiece in color
"The Valley of Diamonds"
(See "Prints")

COLLIER'S MAGAZINE
1907, November 9 / $35-$45

Frontispiece in color
"Landing of the Brazen Boatman"
(See "Prints")

COLLIER'S MAGAZINE
1907, November 30 / $75-$95

Cover in color "Oklahoma Comes In"

COLLIER'S MAGAZINE
1907, December 28 / $5-$10

Advertisement in black and white
"The Fisherman and the Genie"
(See "Prints")

COLLIER'S MAGAZINE
1908, January 11 / $5-$10

Headpiece in black and white
Also a page decoration

COLLIER'S MAGAZINE
1908, January 25 / $55-$65

Frontispiece in color "Circe's Palace"
(See "Prints")

COLLIER'S MAGAZINE
1908, May 16 / $35-$45

Frontispiece in color "Atlas"
(See "Prints")

COLLIER'S MAGAZINE
1908, June 6 / $85-$95

Cover in color "Vaudeville"

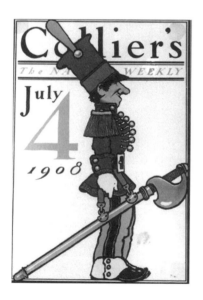

COLLIER'S MAGAZINE
1908, July 4 / $95-$125

Cover in color "A Funnygraph"
Also a black and white page heading

COLLIER'S MAGAZINE
1908, July 18 / $80-$95

Cover in color "The Botanist"

COLLIER'S MAGAZINE
1908, August 8 / $75-$85

Cover in color "Pierrot's Serenade"
(See "Prints")

COLLIER'S MAGAZINE
1908, September 12 / $85-$95

Cover in color "School Days"

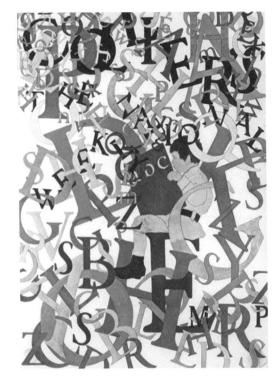

COLLIER'S MAGAZINE
1908, October 31 / $75-$95

Frontispiece in color "Cadmus
Sowing the Dragon's Teeth"
(See "Prints")

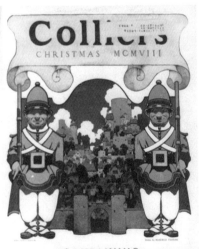

COLLIER'S MAGAZINE
1908, December 12 / $95-$125

Cover in color "Toyland"
Also an illustration entitled "The Knight"

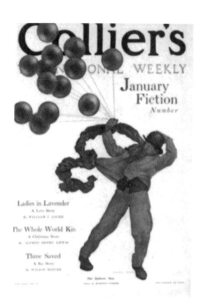

COLLIER'S MAGAZINE
1908, December 26 / $85-$95
Cover in color "The Balloon Man"

COLLIER'S MAGAZINE
1909, January 2 / $100-$125
Cover in color "The Artist"

COLLIER'S MAGAZINE
1909, March 20 / $85-$95
Cover in color "Mask and Pierrot"

COLLIER'S MAGAZINE
1909, March 27 / $5-$10
Decoration in black and white for
"A Submarine Investigation"

COLLIER'S MAGAZINE
1909, April 3 / $75-$85
Cover in color "April Showers"

COLLIER'S MAGAZINE
1909, April 17 / $85-$110
Cover in color "The Lone Fisherman"
Also a black and white page decoration

COLLIER'S MAGAZINE
1909, April 24 / $95-$125
Cover in color "Old King Cole"
(center panel - St. Regis)

COLLIER'S MAGAZINE
1909 May 1 / $75-$85
Cover in color "The Artist" (male)

COLLIER'S MAGAZINE
1909 May 15 / $50-$75
Frontispiece in color "The Chimera"
(Bellerphon by the Fountain of Pirene)
(See "Prints")

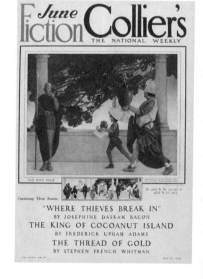

COLLIER'S MAGAZINE
1909 May 29 / $85-$110
Cover in color "Old King Cole"
(right panel - St. Regis)

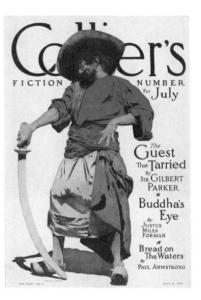

COLLIER'S MAGAZINE
1909, June 26 / $90-$110
Cover in color "The Pirate"

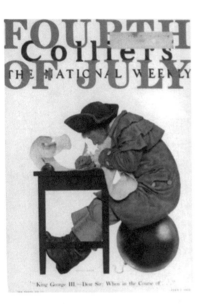

COLLIER'S MAGAZINE
1909, July 3 / $85-$110

Cover in color "Young America Writing
Declaration of Independence"
Also includes an advertisement in black
and white of "Toyland" poster and jigsaw
puzzles of various prints

COLLIER'S MAGAZINE
1909, July 10 / $85-$95

Cover in color "The Tourist"
Also an advertisement for
The Arabian Nights prints

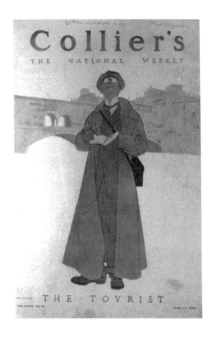

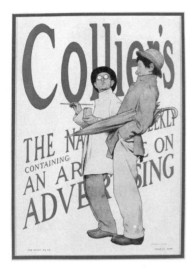

COLLIER'S MAGAZINE
1909, July 24 / $85-$110
Cover in color "The Signpainter"

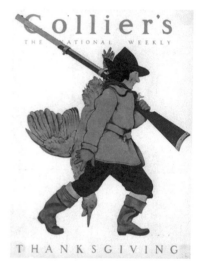

COLLIER'S MAGAZINE
1909, October 16 / $45-$60
Frontispiece in color "Pandora"
(See "Prints")

COLLIER'S MAGAZINE
1909, November 20 / $95-$125
Cover in color

COLLIER'S MAGAZINE
1909, December 11 / $95-$125
Cover in color "The Wassail Bowl"
(See "Prints")

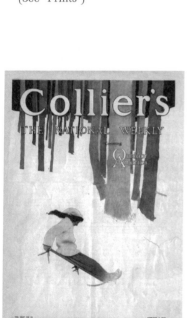

COLLIER'S MAGAZINE
1910, January 8 / $95-$125
Cover in color

COLLIER'S MAGAZINE
1910, March 5 / $45-$60

Frontispiece in color "Quest of the Golden Fleece"
(See "Prints")

COLLIER'S MAGAZINE
1910, April 23 / $45-$65

Frontispiece in color "Proserpina and the Sea Nymphs"
(See "Prints")

COLLIER'S MAGAZINE
1910, July 23 / $35-$45

Frontispiece in color "Jason and his Teacher"
(See "Prints")

COLLIER'S MAGAZINE
1910, July 30 / $85-$110
Cover in color "Courage"

COLLIER'S MAGAZINE
1910, September 3 / $85-$95
Cover in color "Penmanship"

COLLIER'S MAGAZINE
1910, September 24 / $85-$95

Cover in color "The Idiot" (Booklover)
(See "Prints")

COLLIER'S MAGAZINE
1910, November 26/ $85-$110
Cover in color

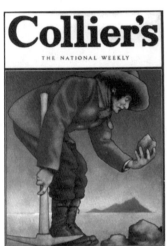

COLLIER'S MAGAZINE
1910, December 10 / $45-$60
Frontispiece in color "The Lantern Bearers"
(See "Prints")

COLLIER'S MAGAZINE
1911, February 4 / $85-$95
Cover in color "The Prospector"

COLLIER'S MAGAZINE
1911, March 11 / $75-$95
Cover in color
"Comic Scottish Soldier"

COLLIER'S MAGAZINE
1911, March 18 / $35-$45
Permanent cover design in color

COLLIER'S MAGAZINE
1911, April 1 / $85-$110
Cover in color "Man with Green Apple"

COLLIER'S MAGAZINE
1911, April 8 / $35-$45
Illustration in color "April"

COLLIER'S MAGAZINE
1911, September 30 / $85-$95
Cover in color "Arithmetic"

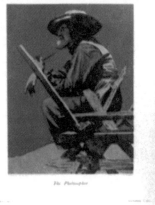

COLLIER'S MAGAZINE
1912, November 2 / $85-$110
Cover in color "The Philosopher"

COLLIER'S MAGAZINE
1912, November 16 / $95-$125
Cover in color

COLLIER'S MAGAZINE
1913, May 10 / $85-$95
Cover in color of man fishing

Collier's, May 17. 1913

COLLIER'S MAGAZINE
1913, May 17 / $70-$85
Cover in color

COLLIER'S MAGAZINE
1913, November 1 / $85-$110
Cover in color

COLLIER'S MAGAZINE
1914, April 6 / $35-$45
Permanent cover design

COLLIER'S MAGAZINE
1929, January 5 / $85-$110
Cover in color "The End"

COLLIER'S MAGAZINE
1929, May 11 / $85-$110

Cover in color "The Knave
Watches Violetta Depart"

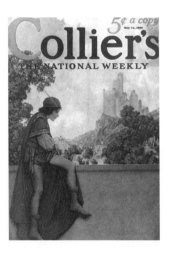

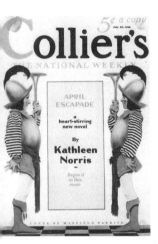

COLLIER'S MAGAZINE
1929, July 20 / $75-$85

Cover in color

COLLIER'S MAGAZINE
1929, November 30 / $75-$100

Cover in color

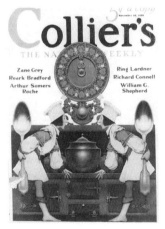

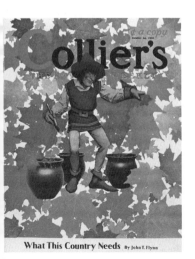

COLLIER'S MAGAZINE
1936, October 24 / $85-$110

Cover in color "Jack Frost"

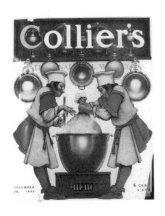

COLLIER'S MAGAZINE
1936, December 26 / $85-$95

Cover in color

THE COSMOPOLITAN
1901, January / $25-$35

Eight illustrations and cover design
in black and white from *Knickerbocker's
History of New York*

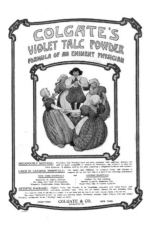

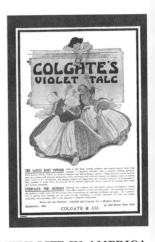

COUNTRY LIFE IN AMERICA
1903, April / $85-$125

Colgate's Violet Talc Powder
Color advertisement

COUNTRY LIFE IN AMERICA
1904, July / $85-$125

Colgate's Violet Talc Powder
Advertisement in yellow

COUNTRY LIFE
1919, August / $75-$95

Advertisement in color for
Fisk Tires "Mother Goose"

THE CRITIC
1896, May 16 / $50-$75

Illustration in black and white of
prize-winning poster for *Century
Magazine* Midsummer Holiday Number
(See "Posters")

THE CRITIC
1896, April 4 / $85-$95

Illustration in black and white of
prize-winning poster of a girl on a bicycle
(See "Posters")

THE CRITIC
1905, June / $45-$65

Article about Parrish containing five
illustrations of his work, photographs
of his home and shop, and a postage
stamp design

DELINEATOR
1921, August / $95-$125

Advertisement in color for
Djer-Kiss (girl on a swing)

DELINEATOR
1922, March / $75-$95

Advertisement in color for
Jello "The King and Queen"

EVERYBODY'S MAGAZINE
1901, December / $25-$35

Frontispiece in black and white for the
story "The Temptation of Ezekiel"

EVERYBODY'S MAGAZINE
1903, May / $10-$15

Illustration in black and white for the story
"The Growth of the Blood Thirst"

THE FARMER'S WIFE
1922, November / $75-$95

Advertisement in color for
Jello "The King and Queen"

GOOD HOUSEKEEPING
1925, July / $30-$40

Advertisement in sepia for Maxwell House
Coffee "The Broadmoor"

HARPER'S BAZAR
1895, Easter / $150-$250

Cover

HARPER'S BAZAR
1896, Easter / $40-$50

Advertisement in black and white for
Gold Dust Cleansing Powder

HARPER'S BAZAR
1914, March / $100-$175

Cover in color "Cinderella"
Also an illustration in black and white of
"Cinderella"

HARPER'S BAZAR
1922, March / $75-$95

Advertisement in color for Jello
"The King and Queen"

HARPER'S MONTHLY MAGAZINE
1896, December / $100-$130

Cover in color
Christmas MDCCCXCVI

HARPER'S MONTHLY MAGAZINE
1898, April / $10-$15

Border around photograph used for
"Photographing a Wounded African Buffalo"

HARPER'S MONTHLY MAGAZINE
1898, December / $10-$15

Headpiece in black and white used
several times for the "Contents"

HARPER'S MONTHLY MAGAZINE
1900, December / $65-$85

Permanent cover design in color

HARPER'S MONTHLY MAGAZINE
1900, Christmas / $85-$110
Cover in color

HARPER'S MONTHLY MAGAZINE
1918, December / $65-$80
Advertisement for Community Plate

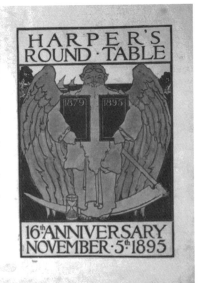

HARPER'S ROUND TABLE
1895, July 2 / $135-$210
Cover in color "Fourth of July"

HARPER'S ROUND TABLE
1895, November 5 / $100-$165
Cover in color
16th Anniversary Number

HARPER'S ROUND TABLE
1896, December / $125-$175
Cover in color

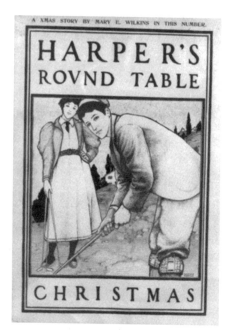

HARPER'S ROUND TABLE
1897, November / $75-$125
Permanent cover design in black and white

HARPER'S ROUND TABLE
1898, December / $75-$110
Cover in black and white

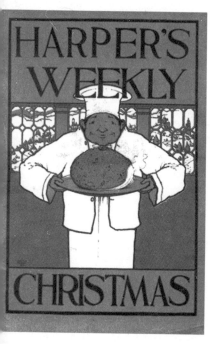

HARPER'S WEEKLY
1895, December 14 / $165-$225
Cover in color

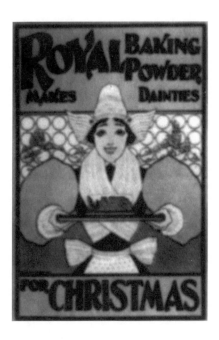

HARPER'S WEEKLY
1895, December 14 / $165-$225

Back cover advertisement in color
for Royal Baking Powder

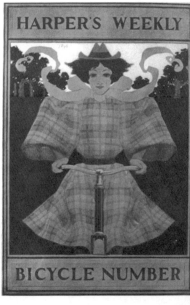

HARPER'S WEEKLY
1896, April 11 / $200-$225

Cover in color
Female bicyclist

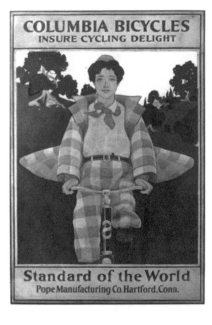

HARPER'S WEEKLY
1896, April 11 / $200-$225

Back cover in color
Male bicyclist

HARPER'S WEEKLY
1896, December 19 / $125-$165
Cover in color

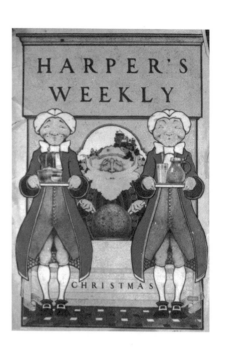

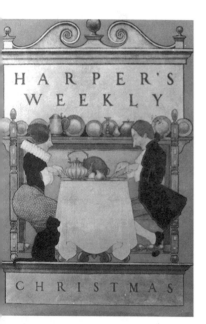

HARPER'S WEEKLY
1897, December 18 / $150-$175
Cover in color

HARPER'S WEEKLY
1900, December 8 / $75-$95
Illustration in color
"His Christmas Dinner"

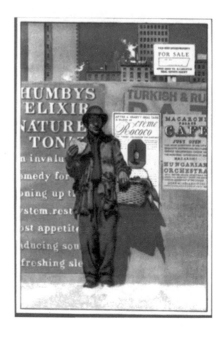

HARPER'S WEEKLY
1906, April 14 / $15-$25

Page decoration for Easter

HARPER'S WEEKLY
1907, December 14 / $85-$115

Same cover design as December 18, 1897, but with different colors

HARPER'S WEEKLY
1908, December 12 / $85-$100

Same cover design as December 14, 1895, but with different colors

HARPER'S YOUNG PEOPLE
1895, Easter / $125-$175

Cover in color

HEARST'S MAGAZINE
1912, June / $165-$200

Cover in color "Jack the Giant Killer"

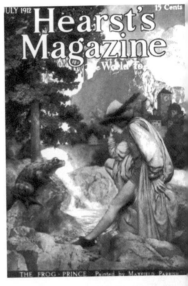

HEARST'S MAGAZINE
1912, July / $150-$210
Cover in color "The Frog-Prince"

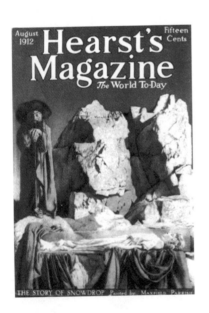

HEARST'S MAGAZINE
1912, August / $175-$225
Cover in color "The Story of Snowdrop"

HEARST'S MAGAZINE
1912, September / $150-$200
Cover in color "Hermes"

HEARST'S MAGAZINE
1912, November / $175-$225
Cover in color "Sleeping Beauty"

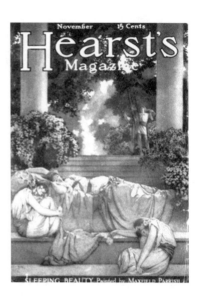

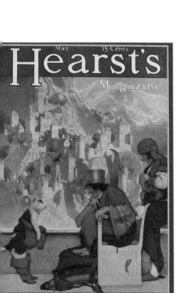

HEARST'S MAGAZINE
1914, May / $175-$225
Cover in color "Puss 'n Boots"

HEARST'S MAGAZINE
1922, March / $75-$95
Advertisement in color for Jello
"The King and Queen"

HOUSE AND GARDEN
1904, April / $50-$60
Four illustrations in black and white of
decorations in the Mask and Wig Club

HOUSE AND GARDEN
1923, December / $75-$95
Advertisement in color for Jello
"Polly Put the Kettle On"

HOUSE BEAUTIFUL
1923, June / $20-$25
Illustration in black and white
"The Spirit of Transportation"
(See "Prints")

ILLUSTRATED LONDON NEWS
1910, November 21 / $75-$100
Two illustrations in color, both
from the book *Dream Days*

ILLUSTRATED LONDON NEWS
1910, December / $100-$125
Two illustrations in color "Dies Irae"
and "The Reluctant Dragon"

ILLUSTRATED LONDON NEWS
1913, November / $40-$55
Illustration in color "Every Plunge
of Our Bows Brought Us..."

ILLUSTRATED LONDON NEWS
1913, December / $45-$85
Illustration in color
"Its Walls Were as of Jasper"

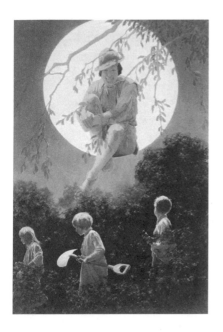

ILLUSTRATED LONDON NEWS
1922, December / $65-$95
Illustration in color "A Departure"

INDEPENDENT
1907, November 21 / $10-$20
Illustration in black and white from the book *Dream Days*

INTERNATIONAL STUDIO
1898, September / $30-$45
Two illustrations in black and white "Old King Cole" and "Wond'rous Wise Man" from the book *Mother Goose in Prose*

INTERNATIONAL STUDIO
1899, December / $15-$20
Illustration in black and white "Jason and Argo" from the book *The Golden Age*

INTERNATIONAL STUDIO
1906, July / $35-$45
Seven illustrations in black and white "A Saga of the Seas," "The Twenty-First of October," "Dies Irae," "The Dinkey-Bird," "Villa Chigi," "It Was Easy to Transport Yourself," "On to the Garden Wall"

INTERNATIONAL STUDIO
1909, February / $15-$25
Photograph in black and white of the poster "Toyland" for art exhibition

INTERNATIONAL STUDIO
1911, January / $65-$85
Illustration in color "Old King Cole" (St. Regis)

INTERNATIONAL STUDIO
1912, August / $15-$25
Two illustrations in black and white from the Florentine Fete murals

JAMA - THE JOURNAL OF THE AMERICAN MEDICAL ASSOCIATION
1974, October 28 / $50-$65
Cover which is an illustration from the chemistry notebook of Maxfield Parrish

LADIES' HOME JOURNAL
1896, July / $125-$185
Cover in color

LADIES' HOME JOURNAL
1901, June / $80-$100
Cover in color

LADIES' HOME JOURNAL
1902, December / $25-$40
Frontispiece in black and white
"The Sugar-Plum Tree"

LADIES' HOME JOURNAL
1903, February / $30-$50
Frontispiece in black and white
"Seein' Things at Night"

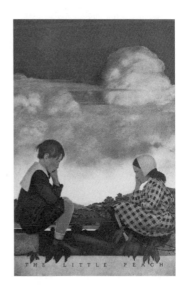

LADIES' HOME JOURNAL
1903, March / $30-$50
Frontispiece in black and white
"The Little Peach"

LADIES' HOME JOURNAL
1903, May / $30-$50
Frontispiece in black and white
"Wynken, Blynken, and Nod"
(See "Prints")

LADIES' HOME JOURNAL
1903, July / $35-$50

Frontispiece in black and white
"With Trumpet and Drum"
(See "Prints")

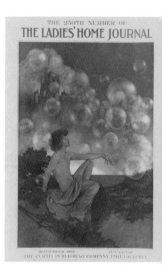

<div align="right">

LADIES' HOME JOURNAL
1904, September / $125-$150

Cover in color "Air Castles"

</div>

LADIES' HOME JOURNAL
1905, March / $20-$25

Illustration in black and white of a circus
design used for a child's bedquilt

LADIES' HOME JOURNAL
1911, November / $25-$40

Announcement of the Florentine Fete murals

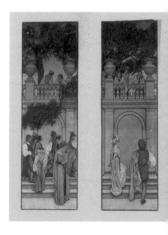

<div align="right">

LADIES' HOME JOURNAL
1912, May / $30-$40

Two illustrations in color "Love's
Pilgrimage" and "Lazy Land" from
the Florentine Fete murals

</div>

LADIES' HOME JOURNAL
1912, July / $85-$110

Cover in color "A Shower of Fragrance"
from the Florentine Fete murals

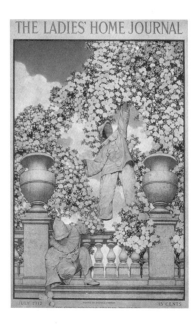

LADIES' HOME JOURNAL
1912, Christmas / $75-$95

Cover in color "A Call to Joy"
from the Florentine Fete murals

LADIES' HOME JOURNAL
1913, May / $85-$110

Cover in color "Buds Below the Roses"
from the Florentine Fete murals

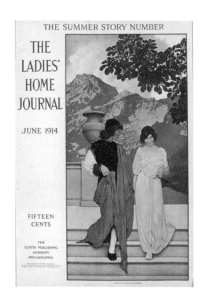

LADIES' HOME JOURNAL
1914, June / $100-$125

Cover in color "Garden of Opportunity"
from the Florentine Fete murals

LADIES' HOME JOURNAL
1915, December / $60-$75

Illustration in color "The Dream Garden"
(See "Prints")

<div align="right">

LADIES' HOME JOURNAL
1916, December / $80-$100

Advertisement in color
for Djer-Kiss Cosmetics

</div>

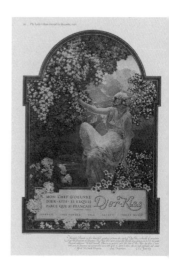

<div align="right">

LADIES' HOME JOURNAL
1918, January / $100-$125

Advertisement in color "And Night is Fled"
(See "E.M. Calendars")

</div>

LADIES' HOME JOURNAL
1918, April / $85-$110

Advertisement in color
for Djer-Kiss Cosmetics

<div align="right">

LADIES' HOME JOURNAL
1918, December / $65-$85

Advertisement in color for Community Plate

</div>

LADIES' HOME JOURNAL
1919, January / $95-$125

Advertisement in color
"Spirit of the Night"
(See "E.M. Calendars")

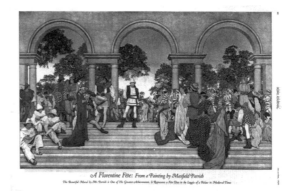

A Florentine Fête: From a Painting by Maxfield Parrish
The Beautiful Mural by Mr. Parrish is One of His Greatest Achievements, It Represents a Fête Day in the Loggia of a Palace in Medieval Times

LADIES' HOME JOURNAL
1920, December / $65-$85

Illustration in color "A Florentine Fete"

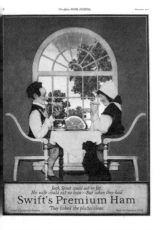

Jack Sprat could eat no fat,
His wife could eat no lean—But when they had
Swift's Premium Ham
They licked the platter clean

LADIES' HOME JOURNAL
1921, April / $175-$200

Cover in color "Sweet Nothings" from
the Florentine Fete murals
Also an advertisement in color for
Djer-Kiss Cosmetics
(See L.H.J. December 1916)

LADIES' HOME JOURNAL
1921, November / $100-$125

Advertisement in color for Swift Ham
"Jack Sprat"

LADIES' HOME JOURNAL
1925, July / $55-$75

Advertisement in color for Maxwell
House Coffee "The Broadmoor"

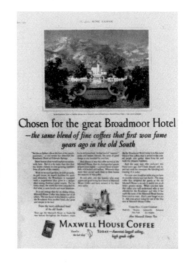

Chosen for the great Broadmoor Hotel
—the same blend of fine coffees that first won fame
years ago in the old South

MAXWELL HOUSE COFFEE

LADIES' HOME JOURNAL
1930, March / $45-$55
Frontispiece in color "White Birch"
(See "Prints")

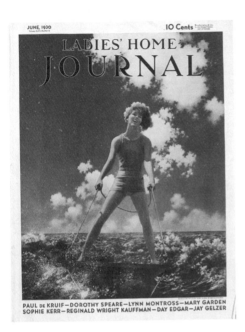

LADIES' HOME JOURNAL
1930, June / $80-$100
Cover in color

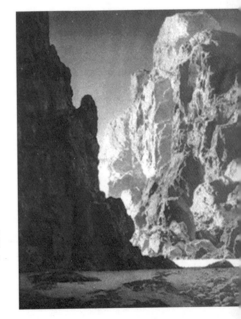

LADIES' HOME JOURNAL
1930, October / $50-$65
Frontispiece in color "Arizona"

LADIES' HOME JOURNAL
1931, January / $95-$125
Cover in color

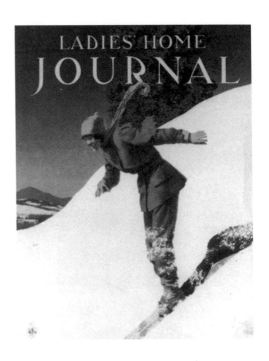

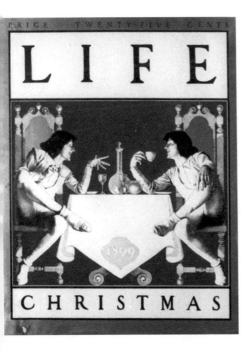

LIFE
1899, December 2 / $145-$200
Cover in color "Christmas"

LIFE
1900, December 1 / $125-$150

Cover in color, Christmas Number
Father Time with clock, book,
hourglass, and two servants

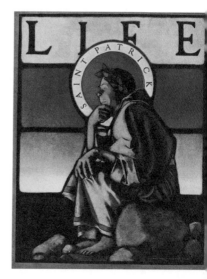

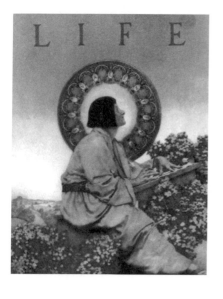

LIFE
1904, March 3 / $100-$125
Cover in color "St. Patrick"

LIFE
1905, February 2 / $100-$125
Cover in color "St. Valentine"

LIFE
1917, September 13 / $50-$65

Advertisement in color for Fisk Tires
"The Modern Magic Shoes"
(See "Posters")

LIFE
1917, November 6 / $50-$65

Advertisement for Fisk Tires

LIFE
1918, May 16 / $50-$65

Advertisement in color for Fisk Tires
"Fit for a King"

LIFE
1919, November 6 / $50-$65

Advertisement for Fisk Tires

LIFE
1920, December 2 / $95-$125
Cover in color "A Merry Christmas"

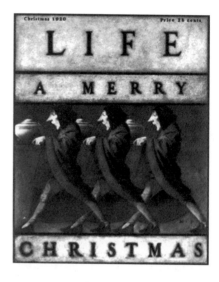

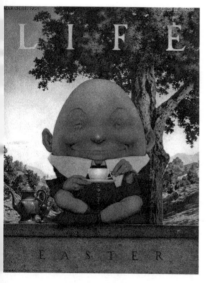

LIFE
1921, March 17 / $225-$325
Cover in color for Easter "Humpty Dumpty"

LIFE
1921, June 30 / $90-$125
Cover in color "A Swiss Admiral"

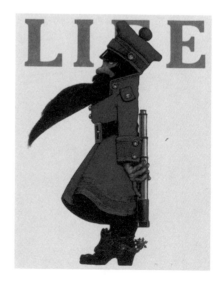

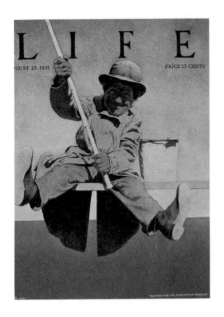

LIFE
1921, August 25 / $90-$125
Cover in color "Fisherman"

LIFE
1921, October 13 / $100-$145
Cover in color "Evening"
(See "Prints")

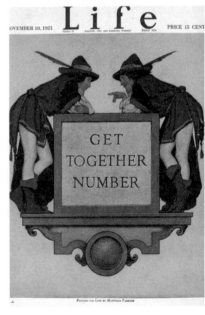

LIFE
1921, November 10 / $85-$100
Cover in color, Get Together Number

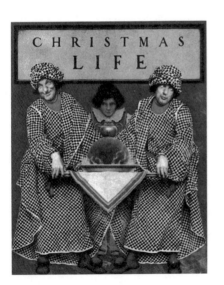

LIFE
1921, December 1 / $100-$125
Cover in color "Christmas Life"

LIFE
1922, January 5 / $100-$125
Cover in color "A Man of Letters"

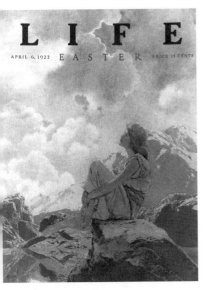

LIFE
1922, April 6 / $110-$135
Cover in color "Morning"

LIFE
1922, May 11 / $90-$110
Cover in color, Bookstuff Number
Proof shown here

LIFE
1922, June 22 / $90-$100
Cover in color "He is a rogue indeed who..."

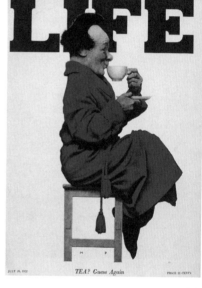

LIFE
1922, July 20 / $100-$125
Cover in color "Tea? Guess Again"

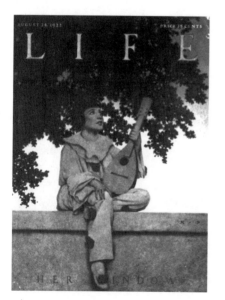

LIFE
1922, August 24 / $95-$125
Cover in color "Her Window"

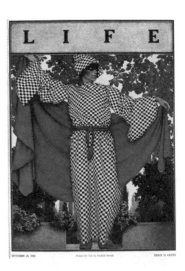

LIFE
1922, October 19 / $95-$125
Cover in color "Masquerade"

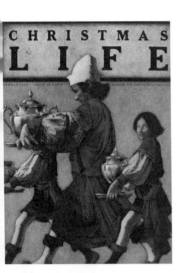

LIFE
1922, December 7 / $110-$135
Cover in color "Christmas Life"

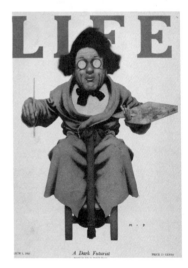

LIFE
1923, March 1 / $100-$125
Cover in color "A Dark Futurist"

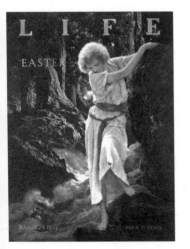

LIFE
1923, March 29 / $125-$150
Cover in color "Easter"

LIFE
1923, August 30 / $110-$125
Cover in color

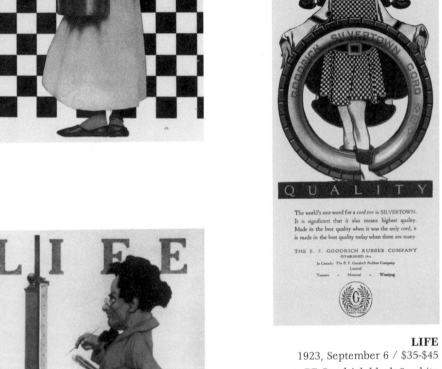

LIFE
1923, September 6 / $35-$45
BF Goodrich black & white
advertisement

LIFE
1924, January 31 / $100-$125
Cover in color "A Good Mixer"

LITERARY DIGEST
1918, May 11 / $25-$35

Advertisement in black and white for Fisk
Tires "Fit for a King"

LITERARY DIGEST
1936, February 22 / $15-$25

Three illustrations in black and white for
"Parrish's Magical Blues"

MAGAZINE OF LIGHT
1931, February / $135-$185

Cover in color "The Waterfall"
(See "E.M. Calendars")

MAGAZINE OF LIGHT
1932, June / $135-$195

Cover in color "Sunrise"
(See "E.M. Calendars")

McCALL'S
1922, March / $75-$95

Advertisement in color for
Jello "The King and Queen"

McCLURE'S
1904, November / $85-$125

Cover in color from the story "The
Rawhide," also contains a black and white
illustration of the cover

McCLURE'S
1904, December / $35-$45

Illustration in color from the story
"The Rawhide"

McCLURE'S
1905, January / $50-$60

Permanent cover design
Also used in 1906 and 1907

THE MENTOR
1914, September / $25-$35

Three illustrations in black and white
from the Florentine Fete murals

THE MENTOR
1922, March / $85-$100

Five illustrations in color from the book
The Arabian Nights "The Fisherman and
the Genie," "Prince Codad," "The King of
the Black Isles," "Cassim in the Cave,"
and "The City of Brass"

THE MENTOR
1927, June / $10-$15

Illustration in black and white "Prince Agib"
from the book *The Arabian Nights*

METROPOLITAN MAGAZINE
1904, December / $15-$20

Illustration in black and white
"Once Upon a Time"

METROPOLITAN MAGAZINE
1906, January / $15-$20

Illustration in black and white
"The Finest Song"

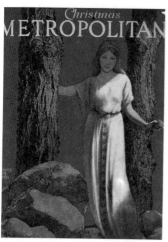

METROPOLITAN MAGAZINE
1917, January / $150-$200
Cover in color

MODERN PRISCILLA
1924, January / $75-$95
Back cover advertisement in color for Jello "The King and Queen"

NATION'S BUSINESS
1923, June 5 / $35-$45
Illustration in color "The Spirit of Transportation"
(See "Prints")

THE NEW COUNTRY LIFE
1918, May / $35-$45
Fisk Tires color advertisement "Fit for a King"

NEW ENGLAND HOMESTEAD
1897, January 2 / $30-$45
Cover in black and white "Happy New Year Prosperity"

NEW HAMPSHIRE TROUBADOUR
1938, April / $15-$20
Illustration in black and white "Land of Scenic Splendor"

NEW HAMPSHIRE TROUBADOUR
1938 Yearbook / $50-$65
Cover in color "Thy Templed Hills"

NEW HAMPSHIRE TROUBADOUR
1939 World's Fair Edition / $65-$75

Cover in color "Thy Templed Hills"
Same as previous entry

NEW HAMPSHIRE TROUBADOUR
1940, February / $60-$75

Cover in color "Winter Paradise"

NEW HAMPSHIRE TROUBADOUR
1940 Yearbook / $60-$75

Front cover, inside front cover and first page

NEWSWEEK
1935, September 28 / $10-$15

Illustration in black and white
"Old King Cole" (St. Regis)

OUTING
1900, June / $75-$100

Permanent cover design in black
and white with colored borders

OUTING
1900 / $60-$85

Permanent cover design used for
numerous issues with and without
color changes in the borders
(Original proof is shown here.)

OUTING

1906, September / $60-$85

Example of permanent cover design
(See previous entry)

OUTING

1907, May / $45-$60

Permanent cover design used for
numerous issues with and without
color changes in the borders and in
the background scene

OUTING

1907, November / $50-$65

Example of permanent cover design
(See previous entry)

THE OUTLOOK
1899, December / $15-$20

Illustration in black and white
"The Roman Road"

THE OUTLOOK
1904, December / $25-$35

Two illustrations in black and white
"The Fly-Away Horse" and "The
Sugar-Plum Tree"

PENCIL POINTS
1935, October / $10-$15

Illustration in black and white
"Old King Cole" (St. Regis)

PICTORAL REVIEW
1924, February / $75-$95

Advertisement in color for Jello
"Polly Put the Kettle On"

THE POSTER
1899, March / $85-$110

Advertisement in black and white
for Adlake Camera
(See "Posters")

PROGRESSIVE FARMER
1952, June / $45-$65
Cover in color "Thunderheads"

RED LETTER
1896, December / $40-$55
Illustration in black and white
"Humpty Dumpty"

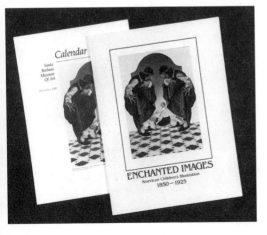

SANTA BARBARA MUSEUM OF ART
1980 / $20-$30

SATURDAY EVENING POST
1913, November 22 / $30-$50

Subscription advertisement in black and white for free reproduction of "Buds Below the Roses" from the Florentine Fete murals

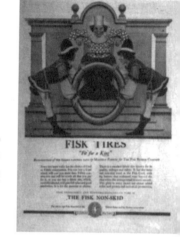

<div align="right">

SATURDAY EVENING POST
1918 / $45-$75

Advertisement in black and white for Fisk Tires "Fit for a King"

</div>

SATURDAY EVENING POST
1918, December 7 / $45-$65

Advertisement in color for Community Plate

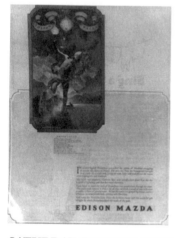

SATURDAY EVENING POST
1920, January 3 / $25-$35

Advertisement in black and white "Prometheus"

<div align="right">

SATURDAY EVENING POST
1921, January 8 / $65-$85

Advertisement in color "Primitive Man"

</div>

SATURDAY EVENING POST
1923, September 1 / $35-$45
Goodrich color advertisement

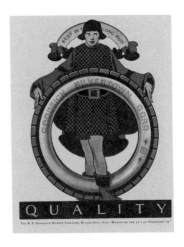

SATURDAY EVENING POST
1925, February 7 / $50-$75
Advertisement in color for Edison Mazda
Used numerous times during the 1920s

SATURDAY EVENING POST
1925, July 4 / $25-$35
Advertisement in sepia for Maxwell
House Coffee "The Broadmoor"

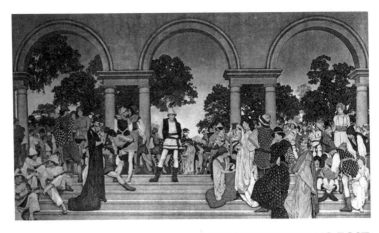

SATURDAY EVENING POST
1925, December 5 / $85-$100
Advertisement in color "A Florentine Fete"

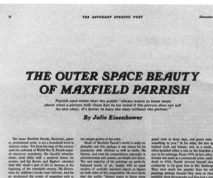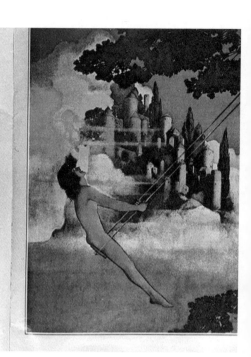

SATURDAY EVENING POST
1974, December / $25-$35
Cover and article

SCRIBNER'S
1897, August / $50-$65

Twelve illustrations in black and white
Story title "Its Walls Were as of Jasper"

SCRIBNER'S
1897, December / $135-$175
Cover in color

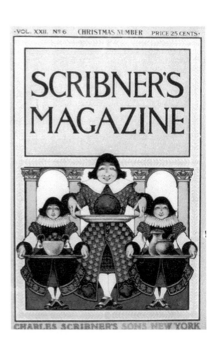

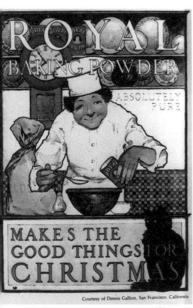

SCRIBNER'S
1897, December / $85-$100

Back cover advertisement in color for
Royal Baking Powder

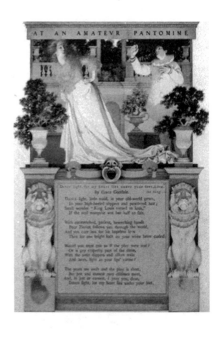

SCRIBNER'S
1898, November / $20-$30

Illustration in black and white
"At an Amatuer Pantomime"

SCRIBNER'S
1898, December / $55-$75

Sixteen illustrations and border designs
in black and white and color from
"The Rape of the Rhine-Gold"

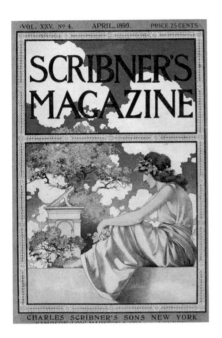

SCRIBNER'S
1899, April / $125-$165
Cover in color

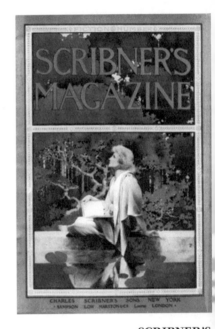

SCRIBNER'S
1899, August / $100-$125
Cover in color

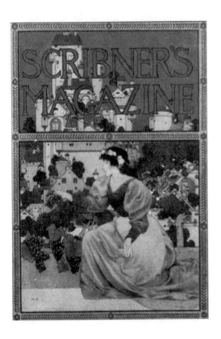

SCRIBNER'S
1899, October / $95-$125
Cover in color

SCRIBNER'S
1899, December / $85-$125
Cover in color

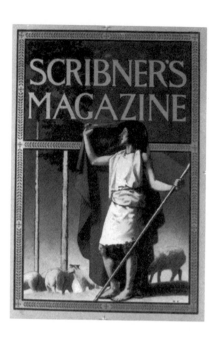

SCRIBNER'S
1900, August / $25-$35

Four illustrations in black and white
One headpiece in black and white

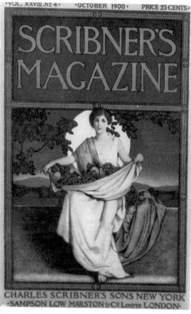

SCRIBNER'S
1900, October / $85-$125
Cover in color

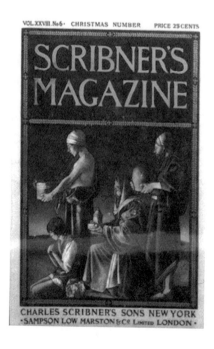

SCRIBNER'S
1900, December / $85-$125
Cover in color

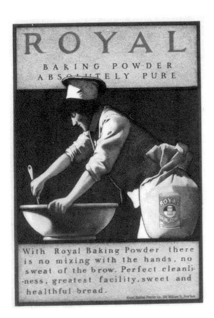

SCRIBNER'S
1900, December / $75-$100

Back cover advertisement in color
for Royal Baking Powder

SCRIBNER'S
1901, August / $50-$75

Seven illustrations, a headpiece and tailpiece
in black and white and color from
"Phoebus on Halzaphron"

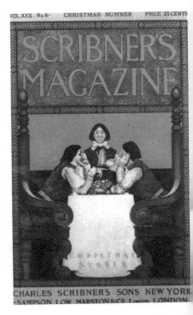

SCRIBNER'S
1901, December / $90-$110

Cover in color

SCRIBNER'S
1901, December / $85-$125

Back cover advertisement in color
for Royal Baking Powder

SCRIBNER'S
1901, December / $45-$55

Frontispiece in color
"The Cardinal Archbishop"
Also two illustrations in black and white

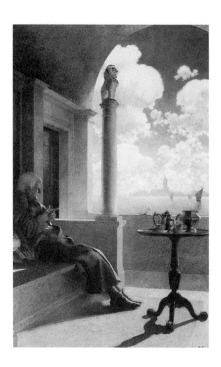

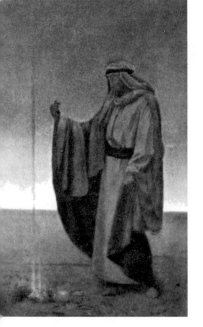

SCRIBNER'S
1902, December / $45-$55

Frontispiece in color "The Desert"

SCRIBNER'S
1903, July / $45-$55

Frontispiece in color "Aucassin
Seeks for Nicolette"
(See "Prints")

SCRIBNER'S
1903, December / $35-$45

Frontispiece in color "Venetian Night's
Entertainment"
Also two headpieces in black and white

SCRIBNER'S

1904, October / $85-$100

Cover in color

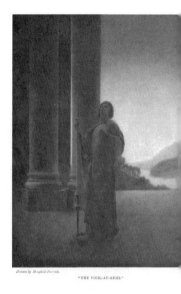

"THE VIGIL-AT-ARMS."

SCRIBNER

1904, December / $35-$

Frontispiece in color "The Vigil-At-Arm

SCRIBNER'S

1905, August / $45-$55

Frontispiece in color "Potpourri"

SCRIBNER'S

1906, April / $35-$45

Frontispiece in color "The Waters of Ven

Two illustrations in color

SCRIBNER'S

1907, August / $45-$55

Frontispiece in color "Old Romance"

CRIBNER'S

10, August / $45-$55

ontispiece in color "The Errant Pan"
ee "Prints")

CRIBNER'S

12, August / $45-$55

ontispiece in color "Land of Make-Believe"
ee "Prints")

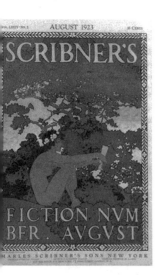

SCRIBNER'S

1923, August / $100-$110

Cover in color

CRIBNER'S

37, January / $45-$55

0th Anniversary Number
ustration in color "The Errant Pan"
ee "Prints")

SPINNING WHEEL

1973, November / $30-$40

Cover in color "Wild Geese"

ST. NICHOLAS
1898, December / $15-$20

Frontispiece in black and white
"Sunny Provence"

ST. NICHOLAS
1903, December / $15-$20

Illustration in black and white from the
story "The Three Caskets"

ST. NICHOLAS
1900, November / $10-$15

Illustration in black and white
"A Quarter Staff Fight"

ST. NICHOLAS
1910, November / $15-$20

Illustration in black and white
"The Sandman"

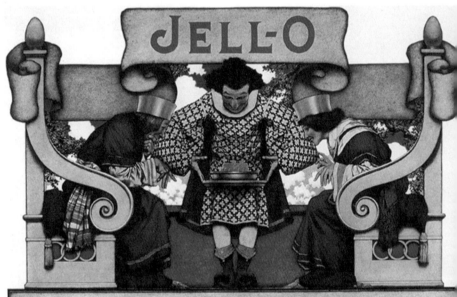

ST. NICHOLAS
1922, March / $65-$85

Advertisement in color for Jello
"The King and Queen"

SUCCESS
1901, December / $95-$125
Cover in color

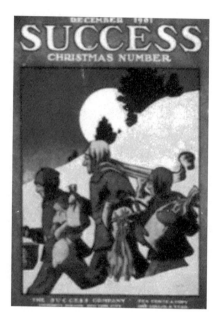

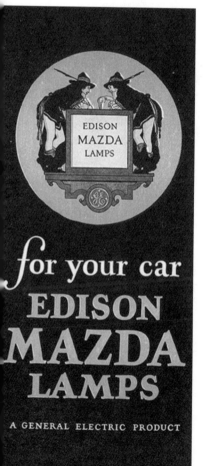

SUCCESSFUL FARMING
1925, May / $35-$50
Advertisement in color
for Edison Mazda

SURVEY
1929, August 1 / $10-$15
Illustration in black and white

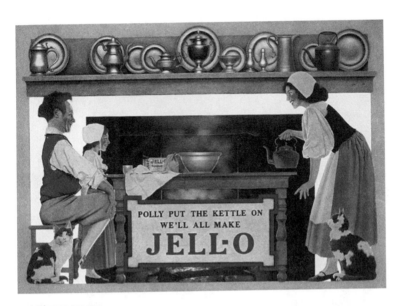

VANITY FAIR
1922, February / $65-$85

Advertisement in color for Jello
"Polly Put the Kettle On"

<div align="right">

WOMAN'S HOME COMPANION
1921, April / $85-$100

Advertisement in color for
Ferry Seeds "Peter Piper"

</div>

THE WORLD'S WORK
1918, February / $95-$125

Advertisement in color "And Night Is Fled"
(See "E.M. Calendars")

THE WORLD'S WORK
1921, June / $45-$55

Advertisement in color for Hires Root Beer
(See "Posters")

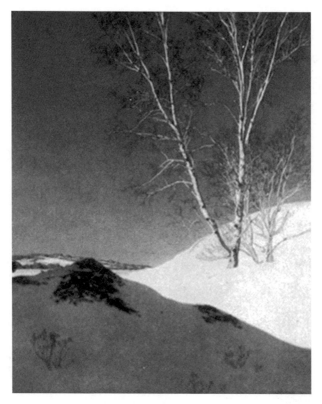

YANKEE
1935, December / $45-$65
Cover in color "White Birch in Winter"

YANKEE
1968, December / $30-$40
Cover "Church, Norwich,
Vermont"

YANKEE
1977, May / $25-$35
Cover "The Gardener"

YANKEE
1979, December / $35-$45

Cover in color
"Evening, Early Snow"

YOU AND YOUR WO
1944, May 13 / $55-
Cover in color "Tranquil

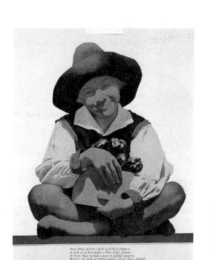

YOUTH'S COMPANION
1919, February 20 / $85-$100

Advertisement in color for
Ferry Seeds "Peter, Peter"

YOUTH'S COMPANION
1924, January 3 / $65-$75

Advertisement in color for Jello
"Polly Put the Kettle On"

POSTERS &
ADVERTISEMENTS

*"...while trying to bring down a mosquito at 11:04
Saturday night, I was wondering how it would do for
the seed poster, to dilate upon the theme of 'Peter, Peter,
pumpkin eater'.... This was not my original idea at
all, but maybe you know yourself how one mosquito
may drive you to almost any length."*

Maxfield Parrish
August 6, 1917

ADLAKE CAMERA
1897 / $2000-$2500

Poster
The Adlake Camera
11 1/4" X 17"

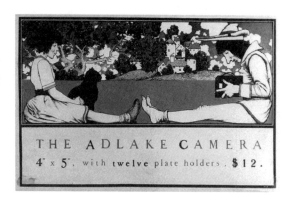

AMERICAN WATER
COLOR SOCIETY
1899 / $1800-$2200

Poster
14" X 22"

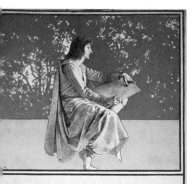

CENTURY MAGAZINE
1897 / $950-$1250

Poster
Midsummer Fiction or Holiday Number
Several reprints were made, 1917 shown
here
14" X 20"

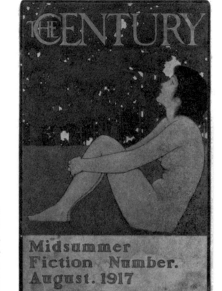

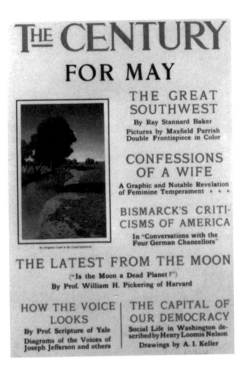

CENTURY MAGAZINE
1902 / $1200-$1600

Poster
An Irrigation Canal
14" X 20"

COLGATE AND COMPANY
1897 / $2400-$2600

Poster
The Dutch Boy
15" X 20"

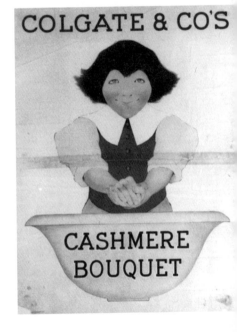

COLLIER'S MAGAZINE
1907 / $2400-$2600

Poster
"Toyland" Toy Show
22" X 28"
(See "Magazines")

COLUMBIA BICYCLES
1896 / $2200-$2600

Poster
Male Bicyclist
12 1/2" X 20"
(See "Magazines")

COLUMBIA BICYCLES
1896 / $2200-$2600

Poster
Female Bicyclist
12 1/2" X 20"
(See "Magazines")

COPELAND AND DAY PUBLISHERS
1897 / $1600-$1900

Poster
"Free to Serve"
A man standing in front of a fireplace
bearing a sign "Emma Rayner"

DJER-KISS COSMETICS
1916 / $850-$1100

Window display advertisement
Girl in a swing
(See "Magazines")

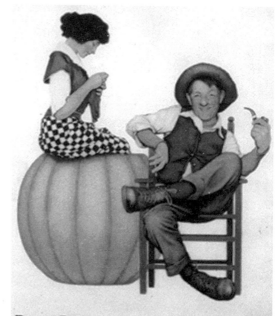

D.M. FERRY COMPANY
1918 / $1200 - $1500

Poster
"Peter, Peter"

Peter Peter pumpkin eater
Had a wife and couldn't keep her
He put her in a pumpkin shell
And there he kept her very well

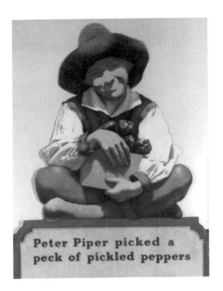

D.M. FERRY COMPANY
1919 / $1200-$1500

Poster
"Peter Piper"
17 1/2" X 22 1/2"

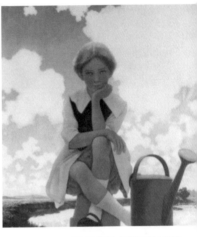

D.M. FERRY COMPANY
1921 / $1600-$1800

Poster
"Mary Mary"
18" X 19 1/2" (image only)

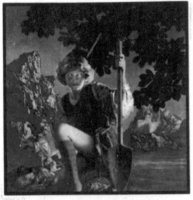

D.M. FERRY COMPANY
1923 / $1800-$2200

Poster
"Jack and the Beanstalk"
19" X 27"

FIRST EXHIBITION OF ORIGINAL WORKS
1925 / $300-$400

Advertising handout
4 1/2" X 5 3/8"

FISK RUBBER COMPANY
1917 / $1000-$1200

Window display advertisement
"Fit for a King"
(See "Magazines")

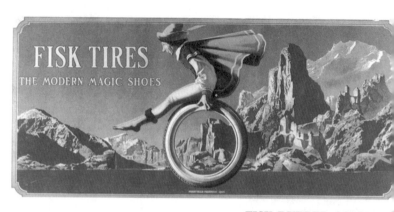

FISK RUBBER COMPANY
1917 / $1000-$140▮
Window display advertisemen▮
"The Modern Magic Shoes▮
13" X 28 1/2▮

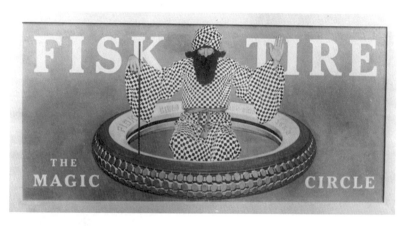

FISK RUBBER COMPANY
1919 / $1000-$1400

Window display advertisement
"The Magic Circle"
5" X 10 3/4"

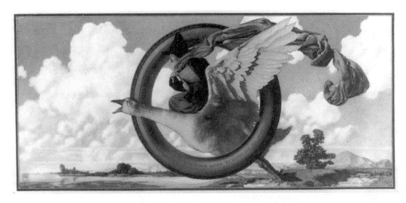

FISK RUBBER COMPANY
1919 / $1400-$1800

Window display advertisement
"Mother Goose"
9 1/2" X 20 1/2"

FISK RUBBER COMPANY
1920 / $1500-$2000

Wallpaper frieze
"Mother Goose"

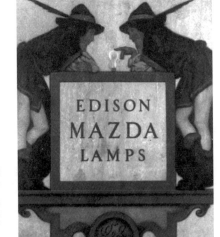

GENERAL ELECTRIC
1920s / $800-$1000

Countertop easel display advertisement
Edison Mazda, Parrish-designed logo
8" X 10"

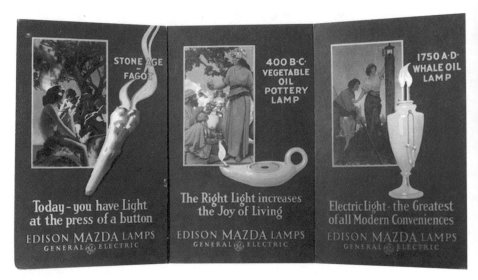

GENERAL ELECTRIC
1929 / $800-$1000 each

Countertop easel display advertisement Edison Mazda Lamp Division
displaying the evolution of light. A series of eight in which three are Parrish
Set of all 8 / $3200-$3600

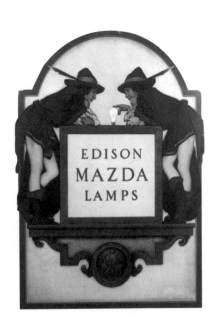

GENERAL ELECTRIC
1920s / $2400-$2800

Window display sign
Edison Mazda, Parrish-designed logo
34" X 47"

GENERAL ELECTRIC
1920s / $2000-$2400

Life-size advertisement
Edison Mazda Lamp Division
62" high

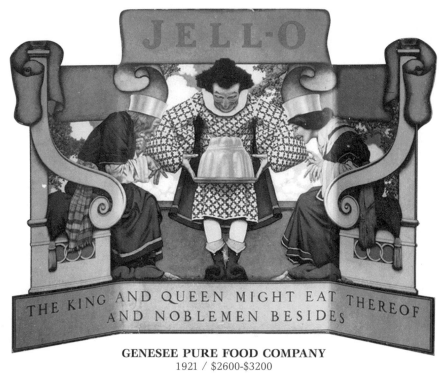

GENESEE PURE FOOD COMPANY
1921 / $2600-$3200

Stand-up advertisement
Jello "The King and Queen"
29 1/4" X 41 1/4"

HARPER'S WEEKLY
1897 / $2000-$2400

Poster
National Authority on Amateur Sport
12 1/4" X 16"

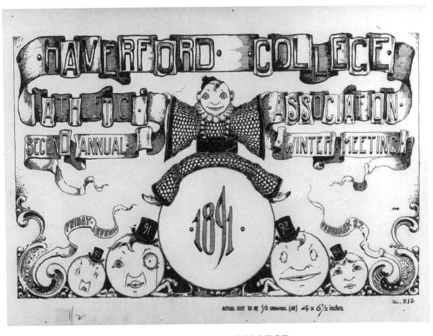

HAVERFORD COLLEGE
1891 / $1000-$1500

Poster/Announcement Athletic Association
Second Annual Winter Meeting
4" X 6 1/2"

HELIOTYPE PRINTING COMPANY
1896 / $2200-$2600

Poster
"Child Harvester"
26 1/2" X 42"

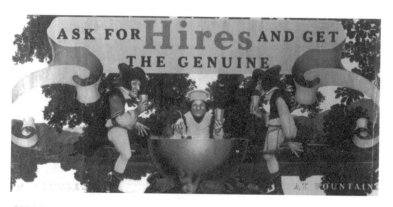

CHARLES E. HIRES COMPANY
1920 / $1100-$1400
Window display advertisement "Ask for Hires"
12 1/2" X 20"

HORNBY'S OATMEAL
1896 / $2200-$2500
Poster
"Hornby's Oatmeal"
28" X 42 1/2"

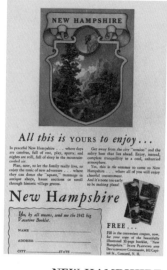

NEW HAMPSHIRE
1942 / $50-$60
Vacation booklet advertisement

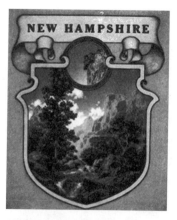

**NEW HAMPSHIRE PLANNING
AND DEVELOPMENT COMMISSION**
1938 / $800-$1000
Poster
"New Hampshire"
18" X 21"

**NEW HAMPSHIRE PLANNING
AND DEVELOPMENT COMMISSION**
1936 / $800-$1000
Poster
"Thy Templed Hills"
(See "B & B Calendars")

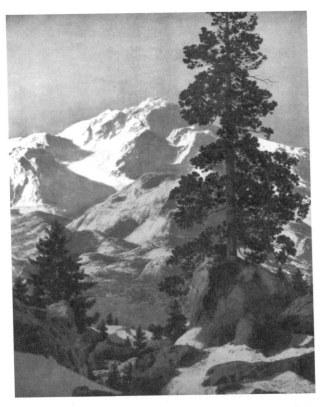

**NEW HAMPSHIRE PLANNING
AND DEVELOPMENT COMMISSION**
1939 / $800-$1000

Poster
"Winter Paradise"
21" X 31"

NO-TO-BAC
1896 / $1900-$2200

Poster
"No-To-Bac"

NOVELTY BAZAAR COMPANY
1908 / $1600-$1800

Poster
"Toy Show and Christmas Present Bazaar"

**PENNSYLVANIA ACADEMY
OF THE FINE ARTS**
1896 / $2200-$2600

Poster
"Poster Show Exhibition"

**PHILADELPHIA HORSE
SHOW ASSOCIATION**
1896 / $2200-$2500

Poster
"Fifth Annual Open-Air Exhibition"

R.H. RUSSELL PUBLISHING
1899 / $1650-$2000

Poster
"Knickerbocker's History of New York"
16" X 24 1/2"

SCRIBNER'S MAGAZINE
1897 / $2500-$3000

Poster
"The Christmas Scribner's"
15" X 22"

SCRIBNER'S MAGAZINE
1897 / $2000-$2500

Poster
"Scribner's Fiction Number August"
14 1/4" X 19 3/4"

SCRIBNER'S MAGAZINE
1899 / $1100-$1400

Poster
Scribner's April Cover
14" X 22"

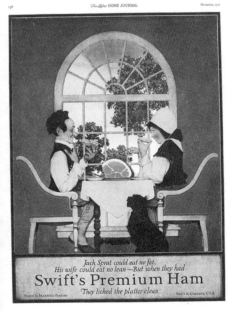

SWIFT AND COMPANY
1919 / $1200-$1600

Poster
"Jack Sprat"
15" X 20"

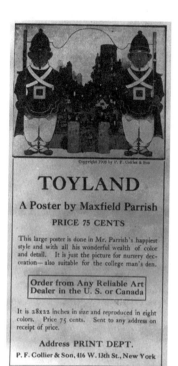

TOYLAND
1908 / $85-$125
Poster Advertisement

**VERMONT ASSOCIATION FOR
BILLBOARD RESTRICTION**
1939 / $900-$1200

Poster
"Buy Products Not Advertised
On Our Roadside"

WELLSBACH LIGHT
1896 / $2400-$2800

Poster
"The Improved Wellsbach Light"

ILLUSTRATED PROGRAMS & RELATED

"I'm no earthly good at the little telling sketch:
the few strokes of the pencil were never my medium:
couldn't (sic) even make a drawing on the Player's
Club table cloths."

Maxfield Parrish
November 27, 1923

**A SELECTED LIST OF NEW
BOOKS FOR THE HOLIDAYS**
1905 / $200-$250

Scribner's catalog cover

BRYN MAWR COLLEGE
1891 / $325-$400

Program cover in color
Bryn Mawr College Lantern

BRYN MAWR COLLEGE
1891 / $325-$400

Theatrical program cover in color

BRYN MAWR COLLEGE
1894 / $325-$400

Theatrical program cover in color

THE DREAM GARDEN
1915 / $55-$65
Pamphlet

EXHIBITION OF PAINTINGS
1925 / $75-$95
Pamphlet

D.M. FERRY COMPANY
1919 / $225-$300

Seed Annual catalog cover
"Peter, Peter"

HAVERFORD COLLEGE
1892 / $300-$375

Cover
Haverford College Grammar School

HAVERFORD COLLEGE
1898 / $275-$350

Cover
Haverford College Athletic Annual

HAVERFORD COLLEGE
1908 / $250-$325

Cover
Haverford Verse

HOWARD HART PLAYERS
1917 / $275-$300

Program cover

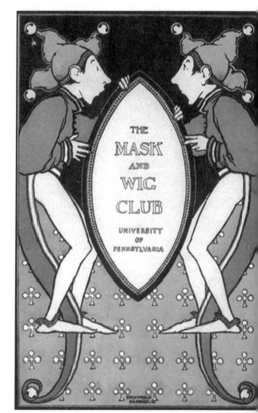

MASK AND WIG CLUB
1895 / $400-$500

Theatrical program cover

MASK AND WIG CLUB
1896 / $450-$550

Theatrical program cover
"No Gentleman of France"

ASK AND WIG CLUB
97 / $350-$450

eatrical program cover
ery Little Red Riding Hood"

ASK AND WIG CLUB
98 / $325-$400

ogram cover
889-1898 Decennial Anniversary
the Mask and Wig Club"

NNSYLVANIA ACADEMY
F THE FINE ARTS
97 / $350-$400

ogram in color
ellowship Ball"

NNSYLVANIA STATE COLLEGE
92 / $350-$400

ass book

HILADELPHIA BOURSE
95 / $350-$400

talog cover

SCRIBNER BOOKS FOR YOUNG READERS
1905 / $225-$300
Catalog cover

**SCRIBNER'S NEW BOOKS
FOR THE YOUNG**
1899 / $300-$400
Catalog cover

TERLING CYCLE WORKS
897 / $325-$400
terling Bicycles
atalog cover

VANAMAKER'S
395 / $350-$400
oliday catalog cover

VANAMAKER'S
396 / $325-$400
ummer catalog cover

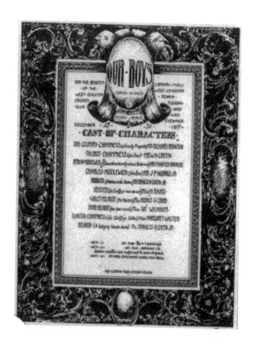

WEST CHESTER CRICKET CLUB
1891 / $350-$400
Playbill
"Our Boys"

MISCELLANEOUS MAGAZINES & CALENDARS

"I wish to Heaven I had a profession that was taken seriously, say, that of a dentist."

Maxfield Parrish
May 24, 1924

MISCELLANEOUS MAGAZINES

F. COLLIER & SON
rious headpieces designed by Parrish
d used frequently during the first
arter of the 20th century.
)-$20 each

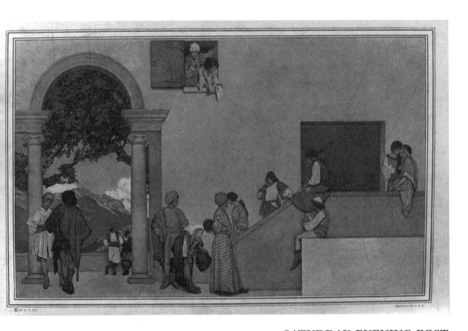

SATURDAY EVENING POST
$250-$350

Gift certificate for subscription "Castle of
Indolence" from the Florentine Fete murals

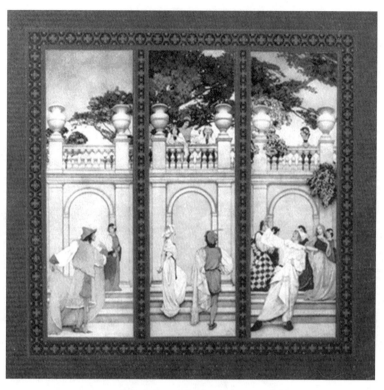

SATURDAY EVENING POST
$300-$350

Subscription card
Three of the Florentine Fete murals

BROWN & BIGELOW
Miscellaneous Calendars

ASTERPIECES
56 / $100-$125 each

landscapes in color:
n Ancient Tree"
aybreak"
vening"
vening Shadows"
.nup"
hy Rocks and Rills"

MY HOMELAND
1964 / $100-$125 each

Six landscapes in color:
"A Perfect Day"
"New Moon"
"Peaceful Valley"
"Sheltering Oaks"
"Sunlight"
"The Mill Pond"

UR BEAUTIFUL AMERICA
)42 / $125-$175 each

eaceful Valley"
wilight"
he Village Brook"
hy Templed Hills"

DODGE PUBLISHING
Miscellaneous Calendars
All calendars measure 6" X 8" / $100-$135 each
With box / $125-$150 each

CALENDAR OF SUNSHINE
1916
"Harvest"

BUSINESS MAN'S CALENDA
19
"Thanksgivin

BUSINESS MAN'S CALENDAR
1921
"Wassail Bowl"

CALENDAR OF CHEER
1921
"Lantern Bearers"

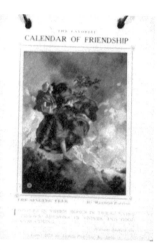

CALENDAR OF FRIENDSHIP
1922
"Search for the Singing Tree"

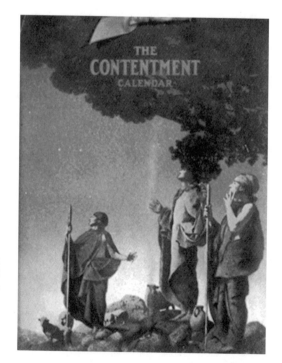

CONTENTMENT CALENDAR
1922
"Three Shepherds"

CALENDAR OF SUNSHINE
1924
"Prince Agib"

SUNLIT ROAD CALENDAR
1924
"Queen Gulnare"

BUSINESS MAN'S CALENDAR
1925

"The Landing of the Brazen Boatman"
(See "Prints")

CALENDAR OF FRIENDSHIP
1925

"Jason and the Talking Oak"

ONTENTMENT CALENDAR
25

ince Agib"
e "Prints")

SUNLIT ROAD CALENDAR
1925
"Land of Make-Believe"

BUSINESS MAN'S CALENDAR
1926

"Cadmus Sowing the
Dragon's Teeth"

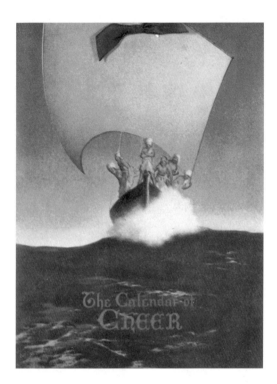

CALENDAR OF CHEER
1926
"Prince Codadad"

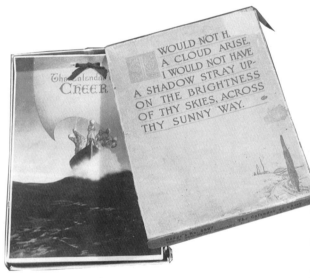

CALENDAR OF CHEE
192
"Prince Codadad" with presentation b

ALENDAR OF FRIENDSHIP
26

rce's Palace"
e "Prints")

ALENDAR OF SUNSHINE
26

arvest"
e "Prints")

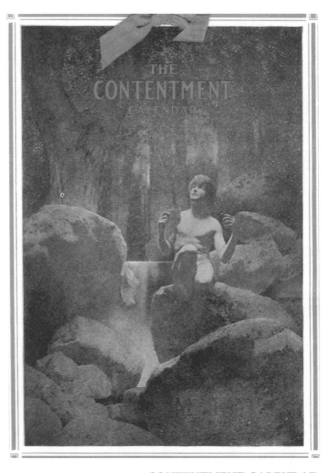

CONTENTMENT CALENDAR
1926
"Summer"

SUNLIT ROAD CALENDAR
1926

"Fountain of Pirene"
(See "Prints")

BUSINESS MAN'S CALENDAR
1927

"Quest for the Golden Fleece"
(See "Prints")

CALENDAR OF CHEER
1927

"Lantern Bearers"
(See "Prints")

CALENDAR OF FRIENDSHIP
1927

"Jason and the Talking Oak"
(See "Prints")

CONTENTMENT CALENDAR
1927

"Land of Make-Believe"
(See "Prints")

SUNLIT ROAD CALENDAR
1927

"Prince Agib"
(See "Prints")

DESK EASEL CALENDARS
1916-1927 / $75-$100 each

From the books *The Arabian Nights,*
A Wonder Book and Tanglewood Tales, and
The Golden Treasury of Songs and Lyrics
With brocade, leather covers / $90-$120 each

THOMAS D. MURPHY
Miscellaneous Calendars

Known sizes are as follows:
Large complete: 21 1/2" X 45 1/2" Small complete: 16 1/2" X 22"
Large cropped: 16 1/2" X 22" Small cropped: 10" X 14"

SUNRISE
937

	Complete	Cropped
Large	$600-$750	$300-$400
Small	$350-$450	$150-$185

(See "E.M. Calendars")

ONLY GOD CAN MAKE A TREE (GOLDEN HOURS)
1938

	Complete	Cropped
Large	$550-$650	$300-$400
Small	$300-$400	$100-$125

DREAMING
1939

	Complete	Cropped
Large	$800-$1000	$450-$650
Small	$400-$500	$150-$200

The Art Calendar Gets More Money Cannot Buy
THE THOS. D. MURPHY CO.
RED OAK, IOWA
THE BIRTHPLACE OF ART CALENDARS

ROCK OF AGES (ARIZONA)
1939

	Complete	Cropped
Large	$500-$600	$300-$350
Small	$300-$400	$100-$150

50TH ANNIVERSARY OF ART CALENDARS

THE THOS. D. MURPHY CO
RED OAK, IOWA
THE · BIRTHPLACE · OF · ART · CALENDARS

WHEN WINTER COMES
(WHITE BIRCH)
1941

	Complete	Cropped
Large	$500-$600	$275-$300
Small	$300-$400	$75-$100

(See "Prints")

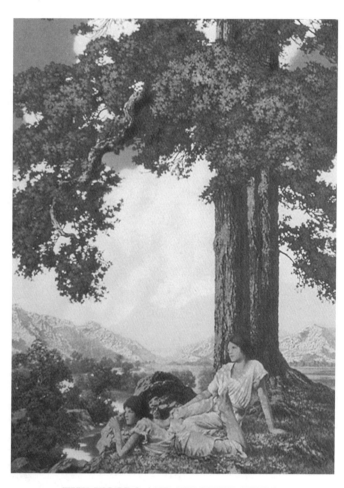

THY WOODS AND TEMPLED HILLS
(HILL TOP)
1942

	Complete	Cropped
Large	$700-$800	$400-$500
Small	$400-$500	$200-$250

CHARLES SCRIBNER'S SON'S
Miscellaneous Calendars

ANDORA
919 / $400-$500
(See "Prints")

**PROSERPINA AND
THE SEA NYMPHS**
919 / $400-$500
(See "Prints")

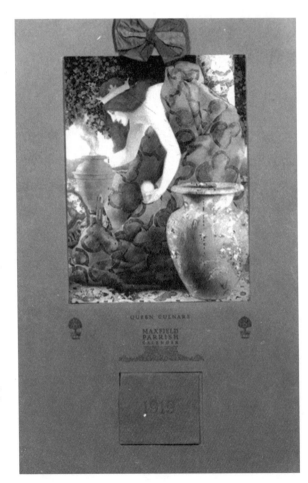

QUEEN GULNARE
1919 / $400-$500

STORY OF A KING'S SON
19 / $375-$475
(See "Prints")

MISCELLANEOUS CALENDARS

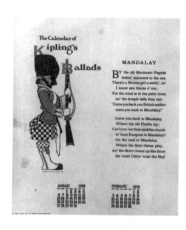

THE CALENDAR OF KIPLING'S BALLADS
1918 / $250-$325

Alternating pages contain one or two comic soldiers

COLGATE & COMPANY
1902 / $200-$300
Pocket calendar

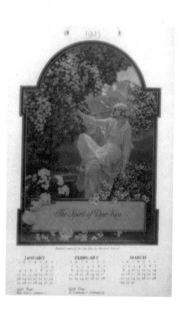

DJER-KISS
1925 / $350-$450

Wall calendar

DODGE PUBLISHING COMPANY
1906-1912 / $75-$100

Various desk top calendars from book illustrations
All have easel backs

EDISON MAZDA
1918-1934 / $100-$125

Wallet calendars in celluloid
One for each year

MISCELLANEOUS SPINOFFS

"It isn't a sketch - it's a peach! - and I heartily congratulate you. I am sending the sketch over now to Mr. Tiffany to see if he will render it into glass. Of course, it is a delicate matter, because not only must I turn down his sketch, but on top of that ask him to render another man's work."

Edward Bok
Ladies' Home Journal
February 11, 1914
To M.P. regarding
"The Dream Garden"

BLOTTER
1924 / $100-$175
Edison Mazda

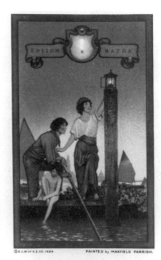

EDISON MAZDA LAMPS

EDISON LIGHT & POWER CO.,
41 W. Market St.,
York, Pa.

OK MATCHES
20s / $10
ɪe Broadmoor Hotel"

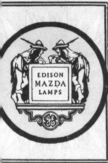

OOK MATCHES
20s / $18
dison Mazda

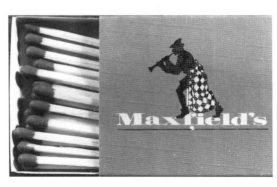

BOOK MATCHES
1930s / $15
Maxfield's

BUSINESS CARDS
1920s-1930s / $45-$60

Edison Mazda Division of G.E.
3 1/4" X 6 3/4"

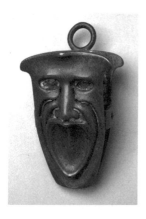

BRONZE MASQUE CLIP
$750-$850
Early 1910s

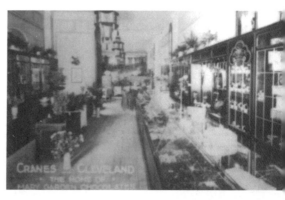

CRANE'S CHOCOLATES RETAIL STORE
Late 1910s

CRANE'S CHOCOLATE BOX
1916 / $500-$700

"Rubaiyat"

CRANE'S CHOCOLATE BOX
1917 / $500-$700

Crane's logo of a crane
(See Tin - Crane's Chocolates
Sign this section)

CRANE'S CHOCOLATE BOX
1917 / $500-$700

"Cleopatra"
(See "Prints")

CRANE'S CHOCOLATE BOX
1918 / $500-$700

"Garden of Allah"
(See "Prints")

Cigar Box lid

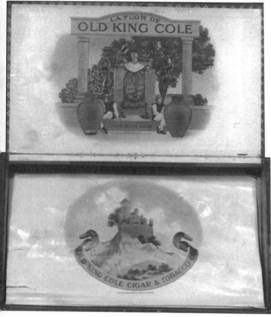

CIGAR BOX
1914 / $650-$800
"Old King Cole"

CIGAR BOX (LABEL)
1927 / $800-$1000
"The Sherman"

FILM/VIDEO CASSETTE

"Parrish Blue"
25 minutes in color
Film / $400-$450
Video cassette / $300-$350

GAME
1913 / $1400-$1800

"Maxfield Parrish Soldier"
Parker Brothers
The Soldier's head drops behind his body
when shot with the (included) air rifle.

TOY SOLDIER (OUT OF THE BOX)
Head is on a spring and rocks back and
forth when hit with dart
(See previous entry)

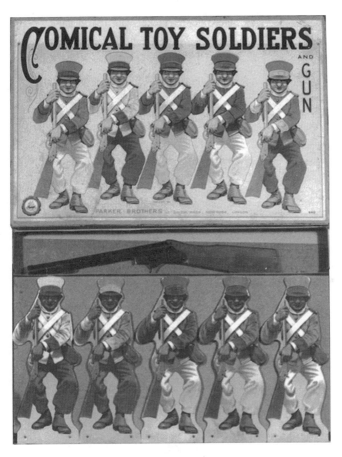

GAME
1921 / $1800-$2000

"Comical Toy Soldiers"
Parker Brothers

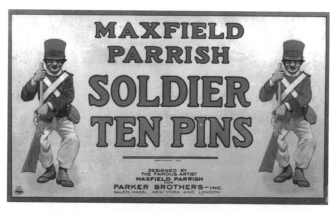

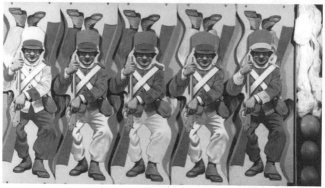

GAME

1921 / $1800-$2000

"Soldier Ten Pins"
Parker Brothers

GESSO AND WOOD WALL PLAQUE
1920s / $150-$185

"Reveries"

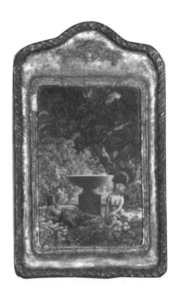

GREETING CARDS
1936-1963 / $35-$75 each

Brown & Bigelow
Landscape and winter scenes
"At Close of Day" (1957)
Winter scene shown here
(See "B&B Calendars")

GREETING CARDS
1918-1934 / $125-$150 each

Edison Mazda
"Sunrise" (1933) shown here
(See "E.M. Calendars")

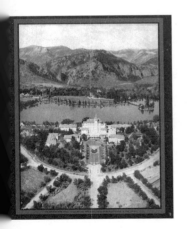

HOTEL BROCHURE
$85-$110

"The Broadmoor"

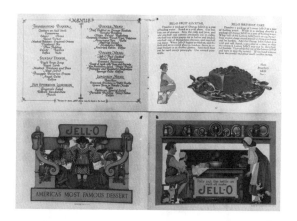

JELLO GELATIN PACKAGE
1920s / $25-$35
"The King and Queen"

JELLO GELATIN PACKAGE
1920s / $25-$35
"Polly Put the Kettle On"

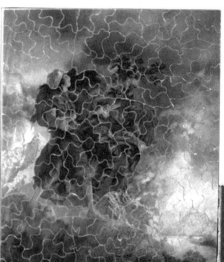

JIGSAW PUZZLE
1909-1910 / $185-$225

The Arabian Nights series
from P.F. Collier & Son
"Search for the Singing Tr[...]
shown here with box

JIGSAW PUZZLE
1970s / $100-$150

"Daybreak"
(See "Prints")

JIGSAW PUZZLE
1920s / $200-$250

"Garden of Allah"

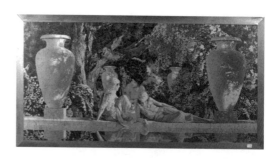

JIGSAW PUZZLE
Mid 1920s / $225-$300

Knave of Hearts
"Knave Watches Violetta Depart"

JIGSAW PUZZLE
Mid 1920s / $225-$300

Knave of Hearts "The Page"
(See "Prints")

JIGSAW PUZZLE
Mid 1920s / $225-$300

Knave of Hearts "The Prince"
(See "Prints")

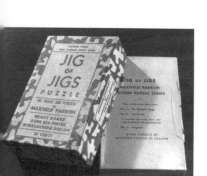

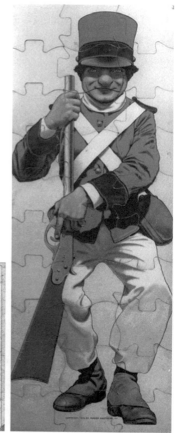

JIGSAW PUZZLE
Mid 1920s / $225-$300

Knave of Hearts
"Lady Violetta and the Knave"

JIGSAW PUZZLE
1913 / $750-$1000

"Komical Soldier"

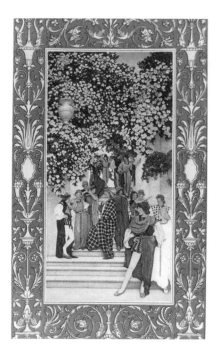

LADIES' HOME JOURNAL
1920s / $75-$95
Subscription gift

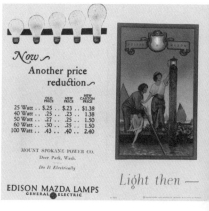

LAMP BOOKLET
1924 / $45-$65
Edison Mazda Lamp

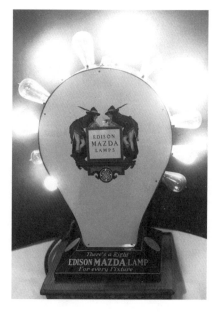

LAMP DISPLAY AND TESTER
1920s / $2500-$3000
Bearing the Parrish-designed
Edison Mazda logo
23" H

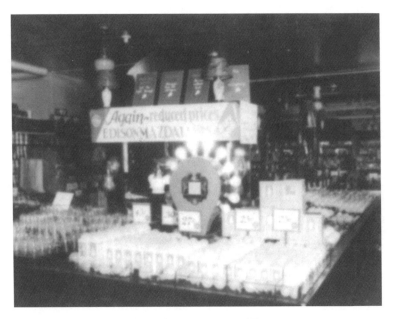

EDISON MAZDA LAMP DISPLAY IN USE
1920s

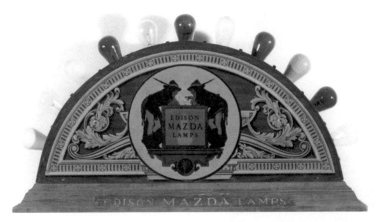

LAMP DISPLAY AND TESTER
1920s / $2000-$2400

Bearing the Parrish-designed
Edison Mazda logo
13" H

LETTER SEAL
1920s / $35-$45
Edison Mazda

LIGHT BULB TIN
1920s / $95-$125

Bearing the Parrish-designed
Edison Mazda logo

Inside view

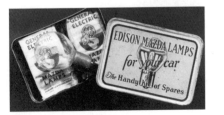

LIPSTICK TISSUE
1920s-1930s / $15-$25
"The Broadmoor"

MAP HOLDER
AUTOMOBILE BLUE BOOK
1924 / $185-$225

MENU
Late 1950s and early 1960s
$225-$350
"The Broadmoor"

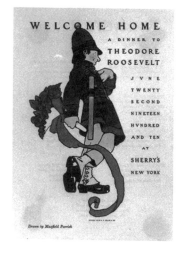

MENU FRONTISPIECE
1910 / $125-$200
"Welcome Home"

PAINTER'S PALETTE
1900s / $1800-$2500
Wanamaker Co.

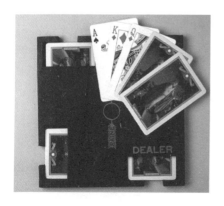

PAINE PLAYING CARDS SET
$350-$400

PLAYING CARDS
1971 / $100-$150 full deck
Brown & Bigelow
"In the Mountains"

"Ecstasy" shown here

"Waterfall" shown here

PLAYING CARDS
Edison Mazda / Full decks

1918 / $300-$365 "And Night is Fled"
1919 / $300-$350 "Spirit of the Night"
1922 / $300-$350 "Egypt"
1923 / $275-$325 "Lamp Seller of Bagdad"
1924 / $225-$275 "Venetian Lamplighter"
1926 / $250-$300 "Enchantment"
1927 / $225-$275 "Reveries"
1928 / $225-$300 "Contentment"
1930 / $250-$300 "Ecstasy"
1931 / $250-$300 "Waterfall"

(See "E.M. Calendars" under each title)

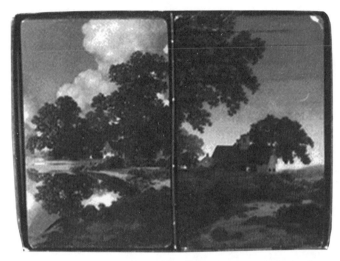

PLAYING CARDS (CANASTA)
1958 / $150-$200 Full deck
"New Moon" (Right)

1960 / $150-$200 Full deck
"Sheltering Oaks" (Left)
Brown & Bigelow

PLAYING CARDS
1950s / $185-$225
"The Broadmoor"

POST CARD
Late 1960s / $35-$50
"Old King Cole" (St. Regis)

POST CARD
1915 / $100-$125
"The Pied Piper"

POST CARD
1920s / $45-$65

"The Broadmoor"
(See "Prints")

POST CARD
1939 / $40-$65

Vermont Association for
Billboard Restriction
(See "Posters")

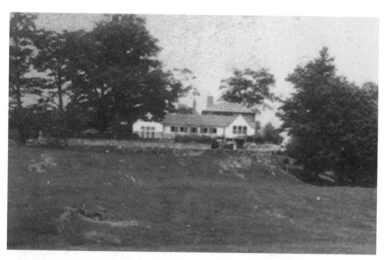

POST CARD
1940s-1950s / $30-$40
Residence of Maxfield Parrish

PRINT PORTFOLIO
1917 / $900-$1000

"A Collection of Colour Prints"
by Geurin and M. Parrish
Italian Villas and Their Gardens
Fifteen prints in color, all matted
(See "Prints")

PRINT PORTFOLIO
1905 / $850-$1000

Maxfield Parrish's Pictures in Color
"The Dinkey-Bird"
"Sugar-Plum Tree"
"With Trumpet and Drum"
"Wynken, Blynken, and Nod"
(See "Prints" under each title)

PRINT PORTFOLIO
1906-1908 / $600-$750

Maxfield Parrish's
Four Best Paintings
"Cassim in the Cave"
"History of the Fisherman and the Genie"
"King of the Black Isles"
"Prince Codadad"
(See "Prints" under each title)

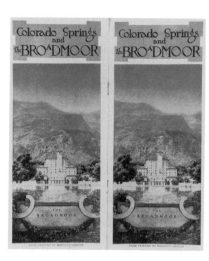

ROOM CARD
1920s / $75-$100

"The Broadmoor"
Hotel booklet with room rates

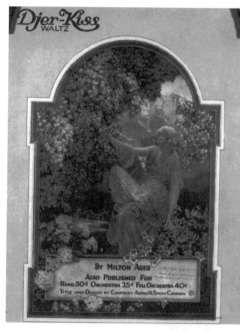

SHEET MUSIC
1925 / $150-$200

"Djer-Kiss Waltz"

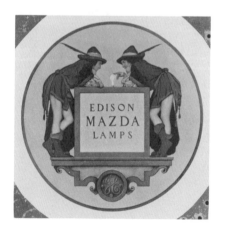

HANGING PORCELAIN SIGN
1920s / $2200-$2800

Edison Mazda Parrish-designed logo
Double sided porcelain on metal

STAMP
Early 1900s / $110-$165
"Get the Habit"

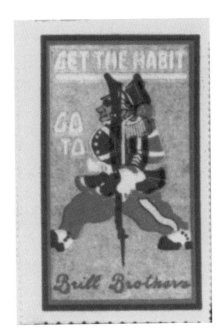

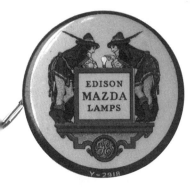

TAPE MEASURE
1920 / $200-$275
Edison Mazda Parrish-designed logo

THERMOMETER
Early 1940s / $150-$200
Thomas D. Murphy Co.
"Arizona"

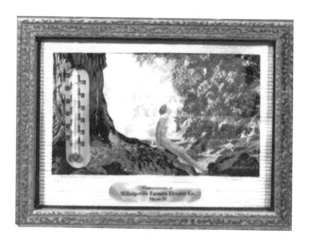

THERMOMETER
Early 1940s / $200-$250

Thomas D. Murphy Co.
"Dreaming"

THERMOMETER
Early 1940s / $150-$200

Thomas D. Murphy Co.
"Golden Hours"
(See "E.M. Calendars")

THERMOMETER
Early 1940s / $175-$225

Thomas D. Murphy Co.
"Sunrise"
(See "E.M. Calendars")

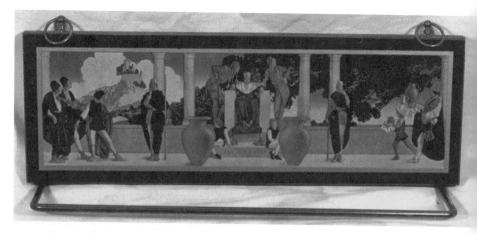

TIE RACK
1909 / $450-$600

Pyraglass Co.
"Old King Cole"

TIN LID
1920s / $200-$225
"The Broadmoor"

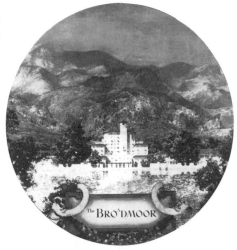

TIN SIGN
1917 / $900-$1000
Crane's Chocolates

TOBACCO PACKAGE
1920s / $225-$300
"Old King Cole"

TOBACCO TIN
1920s / $800-$1200
"Old King Cole"

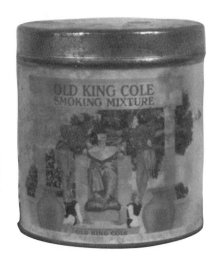

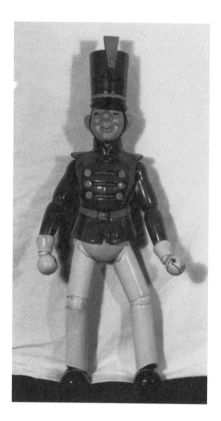

TOY ADVERTISING DOLL
1929 / $950-$1400

General Electric Bandy Doll
(Missing small baton)

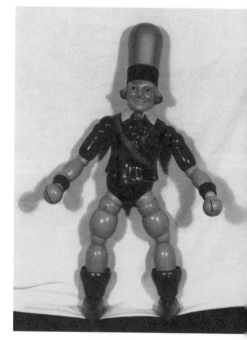

TOY ADVERTISING DOLL
1926 / $1300-$1500

RCA Radiotron "The Selling Fool"
(Slits in hands hold business cards)

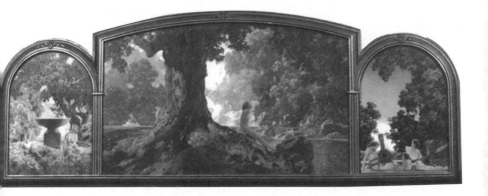

TRIPTYCH
Late 1920s / $1600-$2000

Many different combinations of triptychs are known to exist
Values are determined by adding the individual print values together plus
10-20% for the triptych frame
Example shown here (from left to right):
"Reveries," "Dreaming," and "Interlude"

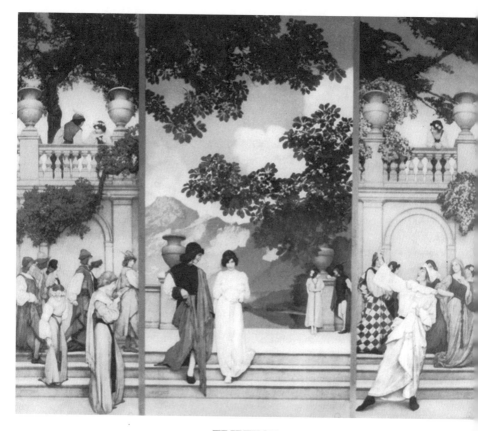

TRIPTYCH
1915 / $1500-$1800

Three of the Florentine Fete murals
From left to right "Love's Pilgrimage," "Garden of Opportunity," and "A Call to Joy"
All printed as one piece, with gold borders surrounding each image
20 1/2" X 24 1/4"

INDEX

bold numbers refer to where the illustrations may be found. The other page numbers
r to where the item has also been mentioned.

FROM THE AUTHOR

"That's a Parrish," the young woman said, pointing at a picture hanging in gallery in the early 1960s.

"No, that's a barn," I said.

"It's a Parrish," she insisted.

"No it's a barn," I proclaimed.

"Maxfield Parrish is the artist and the picture is *Twilight*," she explained.

"Oh," I said.

That was my introduction to one of America's superstars. With my eyes now open to the magical blue in "Stars," "Ecstacy," and ;ty Morn," etc., and the fantasies his art depicts, I became obsessed and ;ht Parrish's work everywhere.

The enchanting images of the "Frog Prince" and "Humpty Dumpty" and subtle humor expressed by the young female "Reluctant Dragon," added to delight at his versatility.

In more than thirty years since, I have collected original paintings, studies, vings, prints, calendars and the unusual such as tin signs, autograph books, ed checks, paper doll cut outs which Parrish painted for his children and :h, much more.

ABOUT THE AUTHOR

Erwin Flacks was born in the Bronx, New York. He attended the Bronx High ool of Science.

He served in the amphibious forces of the U.S. Navy throughout the Pacific ing World War II.

At war's end he moved to California, attended Los Angeles City College and ied his B.A. Degree and teaching credentials at California State University Los ;eles. While teaching in the Los Angeles City Schools, he earned his Master's ree and several additional credentials at California State University Northridge. le studying for his Ph.D. at the University of Southern California he served as ional Vice President of the National Science Foundation.

His teaching career spanned 25 years during which time, in 1963, he ned the Pick-A-Dilly Art Gallery in Sherman Oaks, California. He sold the <-A-Dilly in 1976.

In 1964 he established Fine Art Marketing Company which he currently rates with his wife Gail. During this time they have owned two art galleries, :i, Palm Desert, California, and Erwin Gail Studios, Agoura Hills, California. In ition to presenting internationally known artists, they continue to publish, ribute and sell original paintings, prints, and ephemera.

Erwin currently lives with his wife in Las Vegas, Neveda.